DESERT GARDENS

A PHOTOGRAPHIC TOUR OF THE
Arizona-Sonora Desert Museum

Foreword by Stewart L. Udall

EDITED BY RICHARD C. BRUSCA,
MARK A. DIMMITT, & GEORGE M. MONTGOMERY

COOL SPRINGS PRESS
Growing Successful Gardeners™

BRENTWOOD, TENNESSEE

Published by Cool Springs Press

P.O. Box 2828

Brentwood, Tennessee 37024

EAN: 978-1-59186-458-5

First Printing 2010

Printed in the United States of America

10 9 8 7 6 5 4 3 2 1

Editor: Cindy Kershner

Art Director: Marc Pewitt

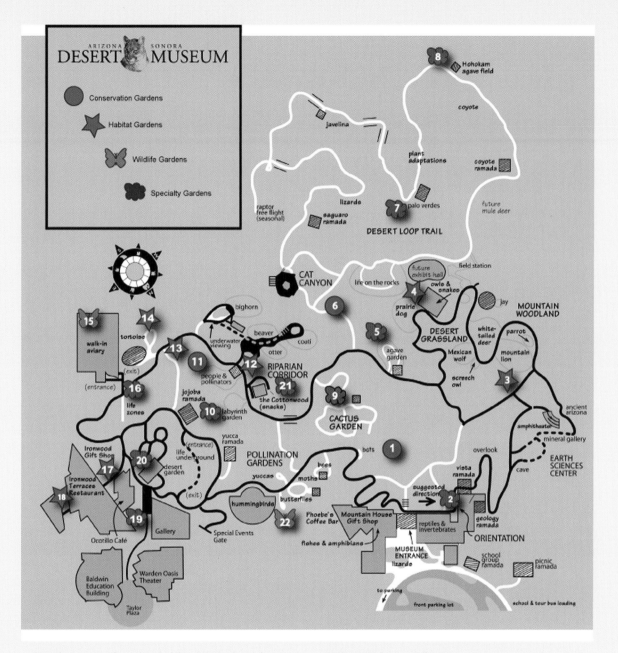

1. **Grounds Center** — This undisturbed desert area has been left in its natural state to allow the visitor a view through the property to Avra and Altar Valleys.

2. **Convergent Evolution** — Using look-alike pairs of plants from unrelated families to demonstrate the phenomenon of convergent evolution.

3. **Mountain Woodland** — This habitat represents plant associations from the Sky Islands of S.E. Arizona.

4. **Desert Grassland** — Plant communities found in the S.E. Arizona and N.W. Sonora grasslands.

5. **Agave Garden** — Display of many of the agaves of our region.

6. **Revegetation** — A formerly disturbed area that has been revegetated to its typical plant association.

7. **Palo Verdes** — Planted examples of several types of our state tree.

8. **Hohokam Agaves** — This hillside is planted with agaves representing a Native American perennial food and beverage crop.

9. **Cactus Garden** — View many cacti and succulents of our region.

10. **Labryinth Garden** — This contemplative walking path is enhanced with native planting beds.

11. **People and Pollinators** — A diverse set of plantings emphasizing the relationships of people and plants.

12. **Riparian Habitat** — Gallery trees and understory plants typical of Sonoran Desert riparian areas.

13. **Mohave Desert** — Features joshua trees and other major features of the Mohave Desert.

14. **Dune Habitat** — This walled sand dune contains creosote and spring wildflowers.

15. **Aviary** — Walk-in aviary with birds and plants. The National Champion Bitter Condalia resides there.

16. **Life Zone Transect** — Eight plots representing a trip up the Catalina Highway, north of Tucson and the lifezones encountered there.

17. **Thornscrub** — An association of plants from the transition habitat Sonoran Desert and Tropical Deciduous Forest.

18. **Tropical Deciduous Forest** — Plants from tropical southern Sonora.

19. **Form and Structure** — A garden that inspires with the diverse shapes of succulents.

20. **Desert Garden** — With its many landscapes, this garden serves to provide ideas for the homeowner and desert gardener.

21. **Yucca Ramada** — A quiet shade ramada with basket weaving plants.

22. **Pollination Garden** — Guilds of plants grouped by pollinator type.

ARIZONA-SONORA DESERT MUSEUM
CONTENTS

III. Educational and Display Gardens at the Desert Museum

Guest Essay

IV. Succulent Gardens at the Desert Museum

V. Resources for Southwest Gardeners

Appendices

FOREWORD

Stewart L. Udall
SECRETARY OF THE INTERIOR 1961–1969

In 1952, when a few committed conservationists founded an institution they called "The Desert Trailside Museum," I was a young lawyer living in Tucson and thinking about running for United States Congress. When I went to Congress in 1955, at the age of thirty-four, the Museum was already a remarkable success story. With ardent nurturing from a diverse group of citizens, the Arizona-Sonora Desert Museum quickly became a first-rate natural history institution and conservation advocate. Today, it is one of the top zoos or museums in North America, and its stunning gardens rank among the best in the world. Those gardens are the subject of this beautiful book.

The Desert Museum is dedicated to the idea of helping people "live in harmony with the natural world by fostering love and appreciation of the

Sonoran Desert." For nearly sixty years it has been educating generations of schoolchildren and visitors about the unique landscapes of the region and the intrinsic values of this precious environment. In doing so, it has instilled a sense of wonder and respect for the many faces of this singular region.

I believe Arizona could make a legitimate claim to being the most distinctive state in the Union. It is, of course, home to Grand Canyon National Park, but that is only the beginning. Its borders embrace more national monuments and congressionally designated Wilderness Areas than any other state in the Union, not to mention countless undesignated breathtaking vistas, from low desert to alpine tundra. Arizona contains a higher percentage of public land than any other state, including over 29 percent owned and managed by Native Peoples. The Tucson area itself can claim distinction as a community that has fought diligently to preserve its surrounding natural landscapes, often with the Desert Museum helping lead the charge.

The Desert Museum has left an environmental legacy through its educational exhibits and conservation programs. Its long history of fighting to protect the Sonoran Desert Region includes key roles in campaigns such as those that helped the National Park Service establish Ironwood Forest National Monument and that helped create a plan to preserve the Isla Rasa island reserve in Mexico. The Museum played key roles in the protection of coastal wetlands in the Sea of Cortez, as well as of large tracts of rare Tropical Deciduous Forest in southern Sonora. Recently it has led public campaigns for sustainable seafoods and for combating the devastating effects of exotic plants, especially introduced buffelgrass that is threatening the future of the entire Southwest.

My life has been dedicated to preserving and protecting America's wildlands and natural recourses, and I believe that a strong environmental consciousness is needed more today than ever. The challenges are great and they will not disappear. As I wrote in my first book *The Quiet Crisis* back in 1963:

"Each generation has its own rendezvous with the land, for despite our fee titles and claims of ownership, we are all brief tenants on this planet. By choice, or by default, we carve out a land legacy for our heirs. We can misuse the land and diminish the usefulness of resources, or we can create a world in which physical affluence and affluence of the spirit go hand in hand."

The Arizona-Sonora Desert Museum is still working to help people understand that a meaningful and prosperous life can go hand-in-hand with environmental awareness.

STEWART L. UDALL
JUNE 2009

INTRODUCTION

Richard C. Brusca

SENIOR DIRECTOR, SCIENCE AND CONSERVATION

Gardening is America's most popular leisure time activity. And, of all the ways people affect and shape the natural world, gardening might be the most natural, caring, and rewarding. Gardens can be so many different things: places of beauty, places that nurture the soul, and places that hold friends and loved ones together in fleeting floral embraces. But gardens can also be places for learning, and in this regard the Arizona-Sonora Desert Museum is renowned for its educational interpretive gardens.

Here is a place where one can stroll through all of the principal habitats that occur in the Sonoran Desert Region—desertscrub, grasslands, riparian habitats, tropical deciduous forest, montane ("sky island") habitats, and more—to observe geology, animals, and plants together in their

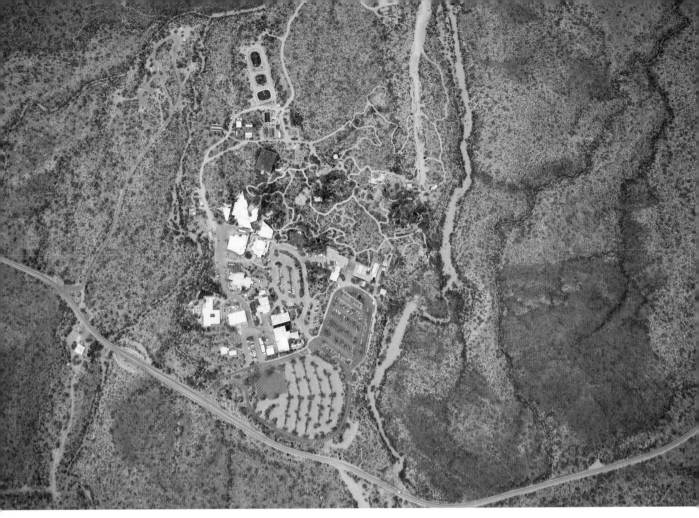

In this aerial view of the Arizona-Sonora Desert Museum, the Desert Loop Trail can be seen at the top of the photograph. The red hill on the right is an outcropping of 150-million-year-old (Jurassic) shale and sandstone.
PHOTO BY D. ARMENTA

natural relationships, interpreted in straightforward ways that inform and encourage appreciation of the natural world.

The Desert Museum was the first major public nature center to adopt this focused, ecological, habitat-based exhibit approach, and it has been a leader in the field for over fifty years. Many other nature centers, such as the Monterey Bay Aquarium (focused on Monterey Bay, California) and Alice Springs Desert Park (focused on the central deserts of Australia), have followed this lead.

The Desert Museum also broke the traditional garden duality of formal versus informal gardens, creating something that is both structured and organized to inform, while simultaneously looking so natural that visitors cannot tell where an exhibit ends and the natural Arizona landscape begins. Embedded in the world's greatest saguaro-palo verde forest, between spectacular Tucson Mountain Park

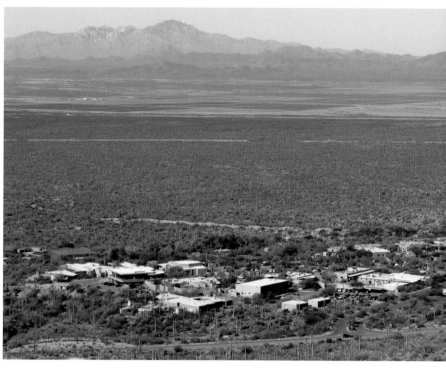

This view of the Desert Museum is looking south, toward the Avra Valley and Baboquivari Mountains. The small white speck on the mountaintop is Kitt Peak National Observatory. PHOTO BY R. BRUSCA

and Saguaro National Park (which, together, encompass an entire mountain range), the Museum is embraced by unspoiled desert on all sides, blending into one of the most spectacular landscapes in all of North America. And, at the core of our work and our exhibits are the gardens, more than thirty of them, reflecting the botanical wonderland that is the Sonoran Desert Region.

It gives us all great pride to see this book published—a celebration of our gardens, our history, our staff, and our way of caring for the Sonoran Desert and all of Earth's landscapes. May it inspire readers to similarly care for their own little piece of desertscape.

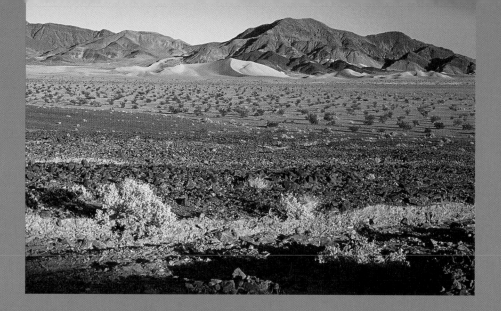

THE DESERT SOUTHWEST

BY MARK A. DIMMITT

T he Desert Museum is somewhat unique among America's gardens, in that many of our displays are habitat-, or biome-based, rather than simply being "artistic." In fact, all eight of the world's biomes occur in southwestern North America, and four of them are represented by major exhibits at the Desert Museum. What exactly is a biome? It is a large-scale biological community defined by climate and dominant vegetation, such as "grassland" or "coniferous forest." *Tundra* is the northernmost biome, characterized by extremely cold winters and dwarf vegetation, and the most equatorial biome is *tropical forest*, characterized by the absence of frost, a very wet rainy season, and a dense forest of tall, often evergreen, trees.

Our biome, *desert*, is the most arid, of course. In deserts, lack of water is extremely limiting to life most of the time, so this biome is characterized by sparse vegetation and species of plants and animals that are adapted to surviving long periods of drought. However, although many

people visualize deserts as desolate wastelands, the term actually defines a wide spectrum of landscapes and plant and animal population densities. While some deserts do have vast seas of sand that are nearly devoid of visible life, some desert areas are more reminiscent of an open woodland—for example, the Arizona Upland subdivision of the Sonoran Desert, where the Arizona-Sonora Desert Museum is located.

Despite their extreme aridity, deserts often support a surprisingly rich assortment of plants and animals. The four North American deserts—Great Basin, Mohave, Chihuahuan, and Sonoran, (which is our habitat and the focus of the Museum)—have different floras and faunas because of their unique combinations of summer heat, winter cold, and rainy

The Great Basin Desert, as seen here east of Adel, Oregon, is the northernmost and oldest of North America's four great deserts and the only cold-temperate desert in North America. Vegetation is sparse and typically dominated by saltbush (*Atriplex*) and sagebrush (*Artemisia tridentata*).

PHOTO BY T. VAN DEVENDER

COMPARISON OF NORTH AMERICAN DESERTS

DESERT	WINTER	SUMMER	RAINY SEASON
Great Basin	❄❄	☀	Effectively Summer
Chihuahuan	❄	☀	Mostly Summer
Mohave	❄	☀☀	Mostly Winter
Sonoran	☀	☀☀	Biseasonal

Opposite — The Mohave Desert is the smallest of North America's four great deserts, and it includes Death Valley as seen here, the lowest point in North America (282 feet below sea level). Some scientists do not regard the Mohave as a distinct desert, but rather a transition between the Great Basin and Sonoran Deserts (or a sub-region of the Sonoran Desert itself). PHOTO BY M.A. DIMMITT

The Chihuahuan Desert is a high desert, mostly above 5,000 feet elevation. PHOTO BY M. A. DIMMITT (TAKEN IN THE GUADALUPE MOUNTAINS OF WEST TEXAS)

seasons. Two life forms—legume trees and large columnar cacti—distinguish the Sonoran Desert from the other three deserts. These two visually dominant plant types enable the Desert Museum to create striking yet people-friendly (shady) desert gardens.

The Sonoran Desert is large, over 100,000 square miles in size (add another 100,000 square miles if you include the Gulf of California in the calculation, the marine half of the Sonoran Desert). Climatologically, the Sonoran Desert differs from the other three North American deserts in two prominent ways: its mild winters and its biseasonal (winter and summer) rainfall pattern. Frost is rare or absent (except for the north-eastern corner of the Arizona Upland). Many of the plants and animals are derived from tropical ancestors

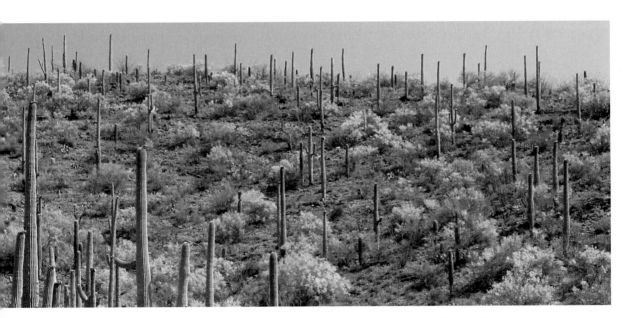

Arizona Upland, seen here near the Desert Museum, is one of six subdivisions of the Sonoran Desert. PHOTO BY M. A. DIMMITT

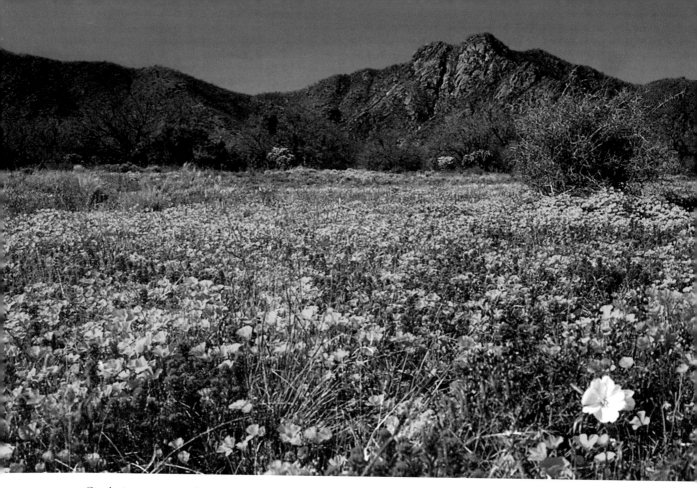

Good winter rains result in massive germinations of annuals in the Sonoran Desert, such as this 2001 floral explosion of desert wildflowers near Kitt Peak in southern Arizona. PHOTO BY M. A. DIMMITT

to the south; their life cycles have adapted to the brief summer rainy season. The winter rains, when ample, support vast numbers of annual flowers, which comprise about half of the plant species. It is rare for both summer and winter rainy seasons to fail, so droughts tend to be less severe in the Sonoran Desert than in the other three North American deserts. The mild winters and two rainy seasons foster a great wealth of plants that we are able to use in the Desert Museum's gardens.

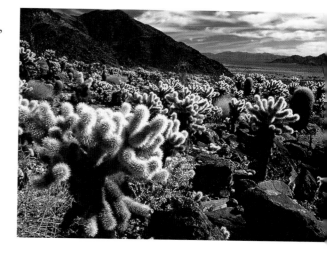

The Lower Colorado River Valley subdivision of the Sonoran Desert supports vast fields of cholla cactus. PHOTO BY M. A. DIMMITT

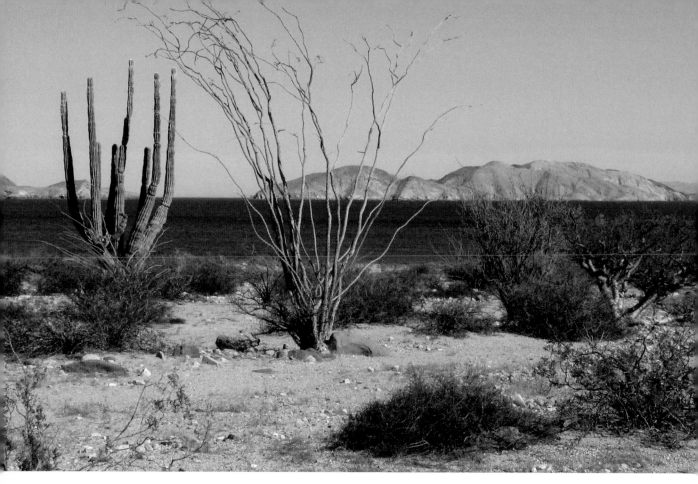

The Central Gulf Coast subdivision of the Sonoran Desert embraces the Sea of Cortez (Gulf of California). Shown here is Bahía de los Angeles, Baja California (Mexico).
PHOTO BY M. A. DIMMITT

The flora varies considerably over the Sonoran Desert's large area, and six vegetative subdivisions are recognized within this region: Arizona Upland, Lower Colorado River Valley, Plains of Sonora, Central Gulf Coast, Vizcaíno, and Magdalena. The first two subdivisions traverse the border, about half of each lying in the United States and half in Mexico. The last four subdivisions are solely in Mexico (in Sonora and the Baja California peninsula). Thus, it is not surprising that this large desert supports a rich diversity of some two thousand species of plants (and about five-hundred-fifty species of vertebrates). If the grasslands, mountains, and tropical lowlands within and adjacent to the Sonoran Desert are included, more than five thousand plant species have been recorded.

When landscaping with Sonoran Desert plants, their geographic and climatic origins must be considered. Those that naturally occur in the colder Arizona Upland subdivision are hardier than those in the rest of this desert, while the tropical members of the Sonoran Desert flora often need winter protection in Arizona Upland areas such as Tucson. Most Sonoran Desert plants will do well only in the warmest regions of the Southwest.

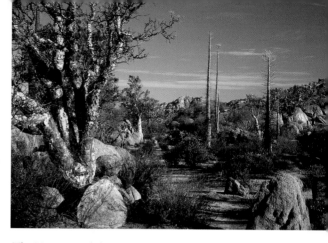

The Vizcaíno subdivision of the Sonoran Desert encompasses the heart of the Baja California peninsula (Mexico). Shown here is the Cataviña area. PHOTO BY M. A. DIMMITT

Other Arid Biomes in the Southwest

The arid and semiarid biomes that surround southwestern deserts also have many plants worth cultivating in our gardens. The mid-elevation valleys support *desert grassland*. *Chaparral* is a shrub-dominated biome that occurs mostly near the coast from central California to northern Baja California. The Southwest also has a wealth of mountain ranges.

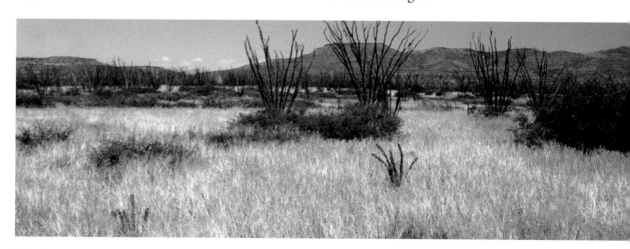

This desert grassland is near Tombstone, Arizona. PHOTO BY M. A. DIMMITT

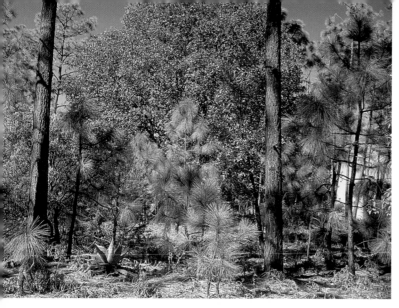

Notice the *Agave shrevei* mixed in with pines (*Pinus engelmannii*) in this mountain woodland, Mesa El Campanero, Sonora (Mexico).
PHOTO BY M. A. DIMMITT

Their middle slopes are clothed with *oak woodlands* and *pine-oak forests*, both semiarid communities. South of the Sonoran Desert in Sonora are two tropical biomes, *thornscrub* and *tropical deciduous forest*. Thornscrub looks much like the Sonoran Desert, but the vegetation is too dense to walk through easily. *Riparian* communities occur

Chaparral occurs mostly in the mountain ranges along the Pacific Coast, as shown here in the San Gabriel Mountains of California. PHOTO BY M. A. DIMMITT

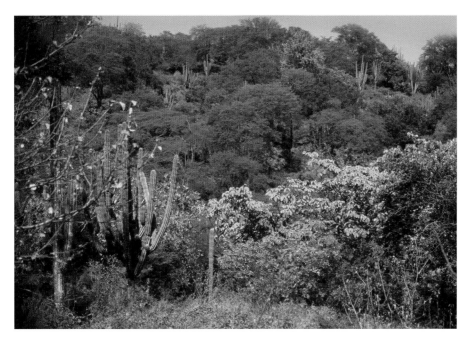

Tropical Deciduous Forest in late summer is quite beautiful, as can be seen in this photo taken near Alamos, Sonora (Mexico). PHOTO BY M. A. DIMMITT

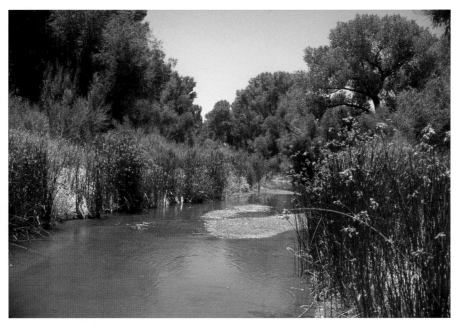

Riparian habitats can be found in all biomes, including the driest deserts of the world. The San Pedro River, shown here at Gray Hawk Ranch, is the last free-flowing river in Arizona. PHOTO BY M. A. DIMMITT

throughout the region, in all vegetation zones. Most montane ("of the mountains") plants do well in Sonoran Desert gardens with some extra water. Tropical plants need both more water and frost protection to thrive in our desert.

As you can see, the Southwest has a wealth of plants that grow in many different habitats! However, it is important to know where they come from in order to use them properly and grow them well in gardens.

Tropical thornscrub habitat is found in southern Sonora. PHOTO BY M. A. DIMMITT

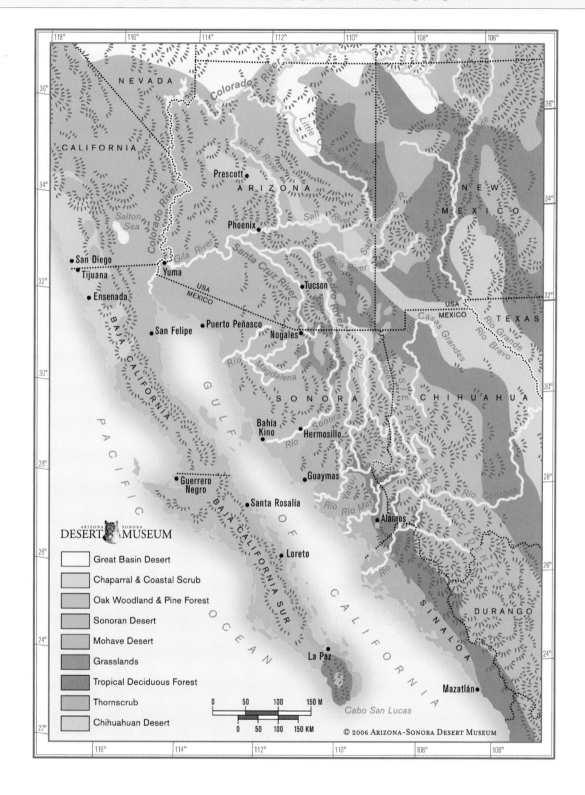

ARIZONA SONORA
DESERT MUSEUM

- Great Basin Desert
- Chaparral & Coastal Scrub
- Oak Woodland & Pine Forest
- Sonoran Desert
- Mohave Desert
- Grasslands
- Tropical Deciduous Forest
- Thornscrub
- Chihuahuan Desert

© 2006 ARIZONA-SONORA DESERT MUSEUM

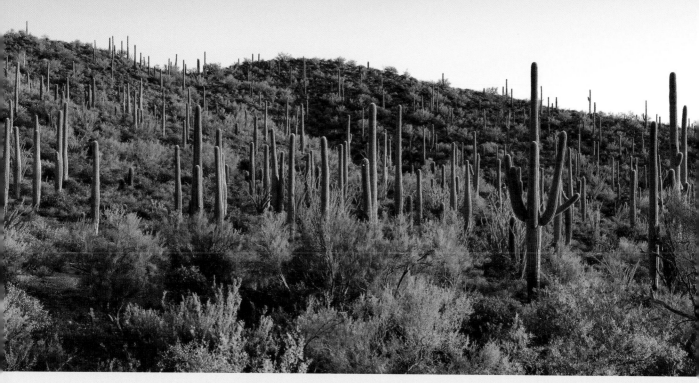

The Desert Museum is set in the Arizona Upland subdivision of the Sonoran Desert. PHOTO BY D. ARMENTA

The Arizona Upland

DANIEL ARMENTA

Visitors driving to the Desert Museum pass through or around the Tucson Mountains. On the steep and curvy road through Gates Pass—the most direct route from Tucson to the Museum and a favorite of sunset junkies and dedicated cyclists—one is greeted by the Arizona Upland in all its splendid glory. The saguaro-choked hillsides are enough to inspire reverence even in veteran desert dwellers, and for people new to this part of the world, it's like arriving on an alien planet. This is part of the allure of the Arizona Upland. It is the beautiful landscape that the Desert Museum calls home.

The Arizona Upland subdivision of the Sonoran Desert extends south from the base of the Mogollon Rim (central Arizona) well into Sonora,

Mexico, where it follows the foothills and bajadas of the Sierra Madre Occidental. The vegetation varies within this large area, yet it is distinct from the other five subdivisions (Lower Colorado River Valley, Plains of Sonora, Central Gulf Coast, Vizcaíno, and Magdalena) because it is the highest and coldest part of the Sonoran Desert, the only subdivision that has numerous freezing nights in the winter. Because of this, many of the plant species in the other subdivisions of the Sonoran Desert cannot survive in the Arizona Upland. (About half of the Sonoran Desert's plants are tropical in origin, but those that occur in the Arizona Upland have adapted to frost.) The upside is that Arizona Upland plants are well adapted to gardens in Tucson and other cities that experience moderate frosts. These hardy plants are much appreciated by gardeners who are weary of covering tender plants on frosty nights.

The Arizona Upland is far wetter than the adjacent Lower Colorado Valley subdivision. The vegetation differs primarily in that saguaros and trees in the Arizona Upland grow most densely on hillsides. The vegetation is so dense in places that some biologists suggest it is more akin to thornscrub than desertscrub. The Arizona Upland offers a rich plant palette for horticulture. In fact, the Tucson Mountain Range alone has a flora of over six hundred species.

Cacti are visually dominant elements of many Arizona Upland landscapes, though they make up a small percentage of the total flora. Saguaro is the king; it grows everywhere except in the lowest valley floors. Two other columnar cacti, organ pipe cactus and senita, occur in the warmest locations. Many species of chollas and prickly pears thrive here, in addition to pincushions, hedgehog cacti, and three species of barrel cacti.

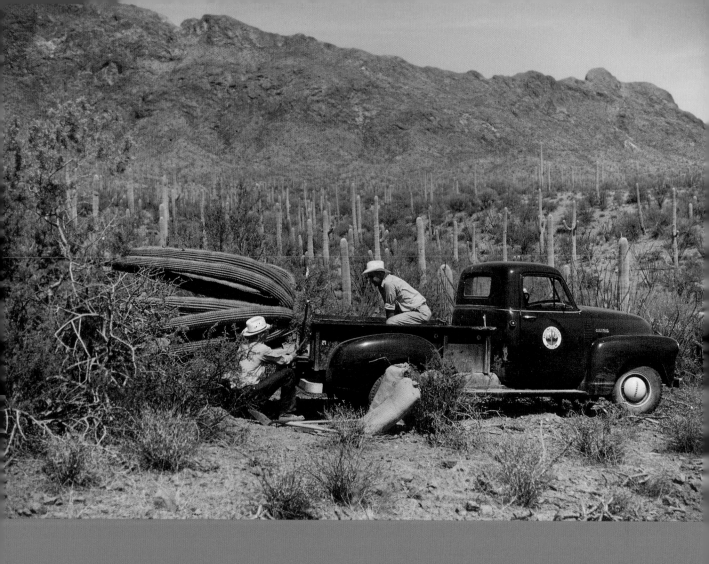

A History of the Desert Museum's Gardens

BY GEORGE M. MONTGOMERY

The Desert Museum's gardens are known for their beauty. This is because the Museum has always stressed the role of plants in its conservation messages and educational stories. From the day we opened in 1952, plants were displayed on an equal footing with animals,

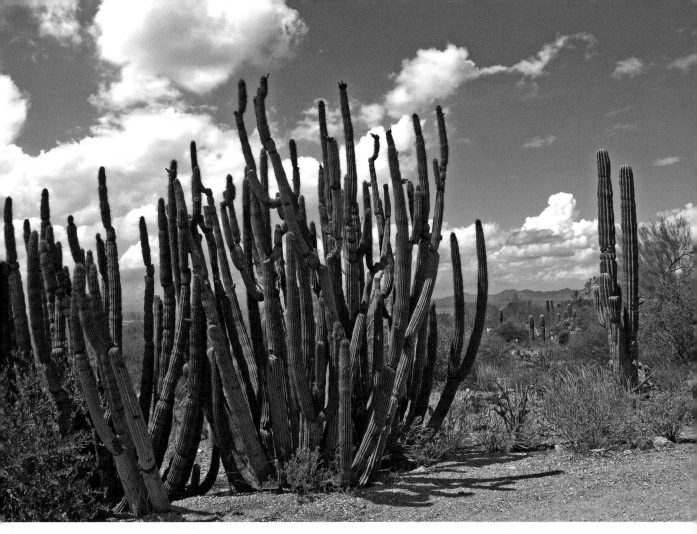

which was unusual at the time. As our gardens have grown over the years, so has the size of our living plant collection, which today holds over fifty thousand specimens of over eleven hundred species, including more than two-hundred-twenty types of cactus, and dozens of threatened and endangered species.

Many illustrious individuals played major roles in shaping the Museum's gardens. George Olin was the first official botanist. From the wild he transplanted many cacti to create the initial botanical trails. The first organ pipe cactus ever planted at the Museum, by Olin, is now more than one hundred years old and towers over visitors when they first enter the Museum grounds.

Opposite — Moving the first organ pipe cactus to the Desert Museum, mid-1950s, was a major undertaking, but today, fifty-five years after being transplanted (*above*), it is a familiar sight at the entrance. PHOTO BY K. DUFFEK

Education has always been an important component at the Museum. Museum co-founder William Carr described the initial plant labels as "baggage tags affixed to cacti and shrubs along the paths," but noted in appreciation the educational component: " . . . our labels pointed out the waxy surface of the cacti and told how the wax helped plants avoid excess evaporation" (Carr 1979).

Alan Blackburn followed and introduced a new style of interactive question-and-answer labels with hinged covers to provide visitors with more information than just plant names. The concept behind these hinged, flip-cover labels is still in use today at the Museum.

Less than a year after opening, Lewis Wayne Walker was employed to fabricate artificial saguaro flowers to show off-season visitors what they missed. We have continued this tradition, and today visitors can see acrylic wildflower blooms year-round.

Paul Shaw was the Museum's botanist through much of the 1950s, and again in the mid-1960s. Under his direction, a significant step forward in showcasing regional plants for gardening came with the construction of the Sunset Magazine Demonstration Desert Garden, which opened in 1963 (see Chapter 7). This garden was the

Artist Greg Brendon's resin models of Sonoran Desert wildflowers show off-season visitors what the flowers look like.
PHOTOS BY G. M. MONTGOMERY

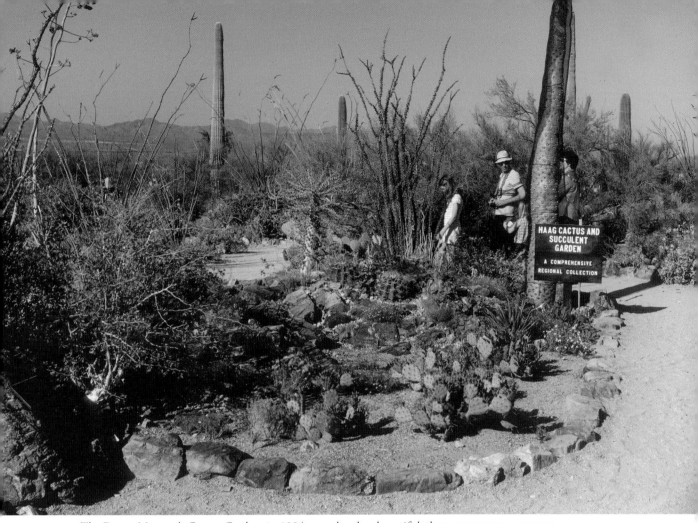

The Desert Museum's Cactus Garden, in 1984, was already a beautiful place. PHOTO BY M. A. DIMMITT

first of the Museum's efforts to demonstrate the use of native plants for home landscaping with an emphasis on water conservation. Another goal of the Desert Garden is to showcase a diversity of hard surfaces (walks, walls, benches) as examples that might be used in home settings. The hard surfaces at the Desert Garden provide an attractive setting for many Museum and private events.

"Cactus" John Haag served as Curator of Botany during the late 1950s, and was instrumental in developing of the Cactus Garden, dedicated in 1965 (see Chapter 13). Haag also co-founded the Tucson Cactus and Succulent Society.

Also under "Cactus" John's supervision, the Museum's first walk-in aviary was built in 1959 (expanded in 1979), requiring research and the planting of many trees from the Sonoran Desert region. Staff of the Boyce-Thompson Arboretum donated and planted many of these original aviary trees (such as canyon hackberry, feather trees, and Texas olives).

The Riparian Corridor exhibits, built between 1967 and 1971 mostly under the supervision of Botany Curator Don Ducote, expanded the list of plants that the Museum could exhibit and interpret. Fremont cottonwood, Gooding willow, Arizona ash, and Arizona walnut formed the canopy.

The Coati Exhibit was added shortly thereafter, modeled after Sycamore Canyon in the Atascosa Mountains of southern Arizona. Climbing trees for the coati include mesquite, ash, canyon hackberry, and blue oak.

Through the 1970s, Cat Canyon and the cave exhibits of the Earth Sciences Center were built and landscaped with plants designed to represent the appropriate cat habitats and the caves' geologic settings. The ocelot, margay, and jaguarundi enclosures were planted with trees, shrubs, and succulents from the thornscrub habitat of southern Sonora, while bobcat canyon was landscaped as Arizona Upland. Because most caves are found in limestone mountains, the Earth Sciences area was planted to represent a limestone hillside in the grassland biome, with its characteristic species of ocotillo, yuccas, and cacti.

This canyon hackberry in the aviary, planted in 1959, still offers shade and berries for birds.
PHOTO BY G. M. MONTGOMERY

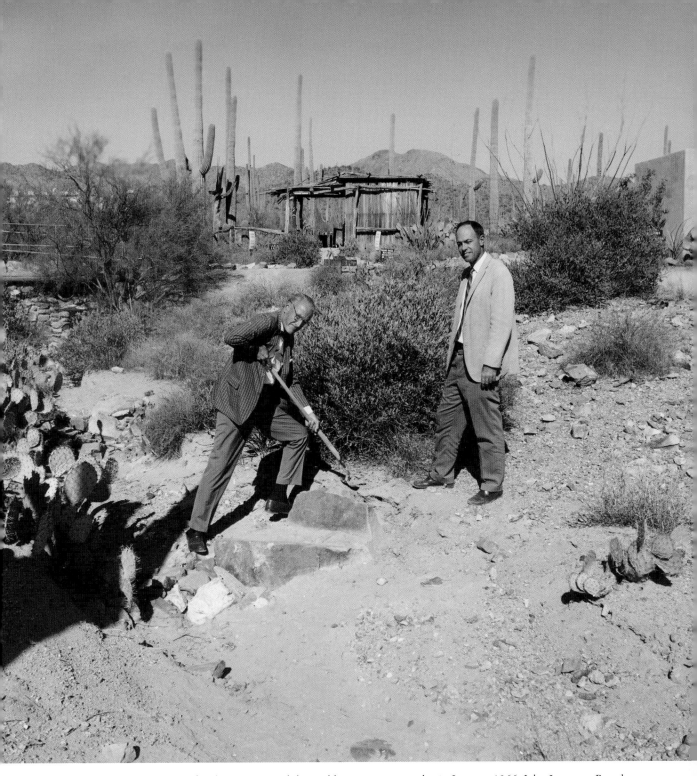

At the groundbreaking for the Riparian Exhibit and beaver-otter complex in January, 1966, John Jameson, Board President (left), and William Woodin, Director, wielded shovels. PHOTO BY ASDM

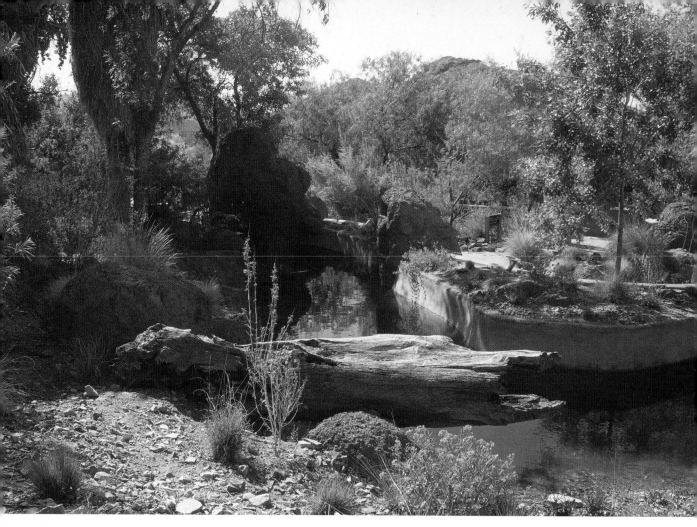

The Coati Exhibit expanded the scope of the Riparian Exhibit. PHOTO BY J. BROOME

The Museum executed extensive expansion of garden exhibits during the 1980s and 1990s. On a small scale, Botany Curator Mark Dimmitt created the Convergent Evolution Exhibit, which became the Museum's first garden to interpret a scientific phenomenon. The "Uncage Our Cats" capital campaign that funded the building of the Mountain Woodlands Exhibit was a large-scale effort. Several more non-desert habitat exhibits followed. The design for the Mountain Woodlands exhibit required over twenty mature oaks. These Emory, Arizona, and silverleaf oaks were transplanted from private and public lands.

The Hummingbird Exhibit was built in 1988, landscaped, of course, with many hummingbird nectar plants (see Chapter 9). The expansion and remodeling of this aviary (1992) coincided with the building of the Desert Grasslands, another total immersion exhibit that added many new species to the Museum's collections.

The Desert Loop Trail Exhibit complex (see Chapter 5) was begun in 1995, and work continues today. In addition to utilizing the existing natural landscape as the foundation for the coyote and javelina exhibits, purely botanical exhibits include a succulent hillside, palo verde grove, and Hohokam agave field. And in 1999, the conversion of the Hummingbird Exhibit into the centerpiece of the much larger Pollination Gardens (see Chapter 10) was conducted under the botanical curatorship of Barbara Skye. These pathways, alcoves, and raised beds display species that are dependent on nectar bats, hummingbirds, moths, butterflies, and other insects for pollination.

At the turn of the century, the Tropical Deciduous Forest (TDF) and Life on the Rocks Exhibits were completed. The TDF continued the regional biocommunity theme, and Life on the Rocks is an artificial rocky cliff face with plants and animals that inhabit boulder fields and cliffs in Arizona Upland Sonoran Desert.

In the first decade of the 2000s, Curator George Montgomery supervised the additions of the Agave Garden, the landscaping of patios and plazas around the new Baldwin Education Building and the new Warden Oasis Theater, and a new ethnobiology exhibit called People and Pollinators.

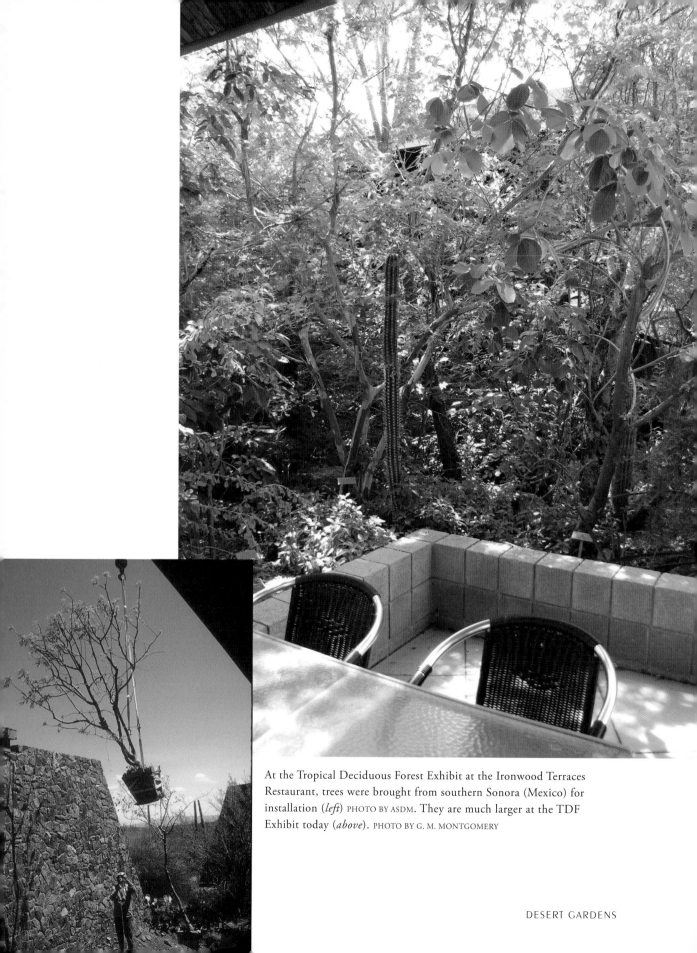

At the Tropical Deciduous Forest Exhibit at the Ironwood Terraces Restaurant, trees were brought from southern Sonora (Mexico) for installation (*left*) PHOTO BY ASDM. They are much larger at the TDF Exhibit today (*above*). PHOTO BY G. M. MONTGOMERY

Taylor Plaza connects the Warden Oasis Theater and Baldwin Education Building. PHOTO BY G. M. MONTGOMERY

Since the Desert Museum's opening in 1952, the botanical staff has created a great variety of garden types, always with a focus on authenticity and accuracy, which has led to the Museum being repeatedly ranked as one of the top gardens in the world.

Warren Jones, ca. 1981

WARREN JONES
FATHER of DESERT LANDSCAPING

ELIZABETH DAVISON
DIRECTOR, UNIVERSITY OF ARIZONA CAMPUS ARBORETUM

Warren Jones, Fellow of the American Society of Landscape Architects, was a consultant to *Sunset Magazine*, a member of the Arizona-Sonora Desert Museum Advisory Board, on the Board of Directors at Boyce Thompson Southwest Arboretum, and an Arizona Trustee for the American Society of Landscape Architects. His career as a Professor of Landscape Architecture at the University of Arizona spanned twenty

years, from 1967 to 1987. His design students, many of whom are well known in the Southwest today, benefited from Warren's knowledge of desert regions gained during his travels to Mexico, the Middle East, and elsewhere.

More than any other professional, Warren influenced the landscape look of the post–World War II American Southwest. Nearly half of the tree and shrub species on the University of Arizona campus can be traced to Warren's quest for plants that would thrive in harsh desert urban environments. During the 1970s, '80s, and '90s, the campus was a proving ground, where species from around the world were evaluated for their suitability to Tucson's landscapes and climate. Many of those trial trees were the first, and are now the tallest or oldest to be planted in Arizona. Several of them have been designated "Great Trees of Arizona" by the Arizona Community Tree Council.

Warren's innovative ideas led to a complete change in the way we feel about native plants in the Southwest. The next time you plant a Baja fairy duster, a Texas olive, or a desert willow, think of Warren and his love of interesting plants, water-efficient landscapes, and natural beauty. We salute you, Warren Jones—truly the "Father of Desert Landscaping."

Gardening and Landscaping in the Desert Southwest

BY DOUG LARSON

The design of gardens and outdoor spaces—for function, beauty, and pleasure—has been a tradition in human cultures for thousands of years. Through the ages, landscape architecture and garden design have been characterized by different styles and influenced by changing fashions, the availability of plants, and ever-improving horticultural techniques. Theories of garden design reflect the artistic interpretations of each historical era and the cultural influences of each region. However,

some historic garden styles originated in a cool, wet environment and are not suitable for the arid Southwest. Other historic garden styles, such as the ancient Persian gardens, walled out the hostile desert in an attempt to create a "paradise on earth." Today, sensibilities toward sustainability and water conservation have altered our attitudes about landscaping in the desert.

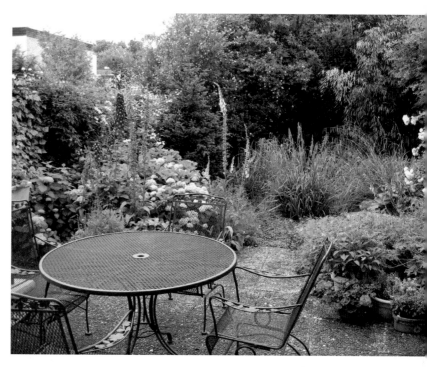

Many historic garden styles, such as this one, are not suitable for the arid Southwest. PHOTO BY D. WRENCH

Opposite — Spanish-colonial hacienda courtyards and gardens are conducive to social gatherings. PHOTO BY C. CONTE

Much of the aesthetic flavor of southwestern gardens today is due to the influence of Spanish colonial gardens that existed in northern Mexico and parts of the southwestern United States in the 1600s and 1700s. Rural haciendas and city blocks were designed as a series of interconnected courtyards enclosed by buildings. Covered walkways opening to the rooms surrounding the courtyard created cooler shaded areas. The cool inner courtyards were for cooking, family gatherings, and relaxation. Over time they evolved into beautiful gardens with potted plants, tile work, ornamental paving, fountains, and large shade trees. These courtyard gardens held many of the same design elements still used successfully in southwestern gardens, both residential and commercial.

Modern Garden Design

Modern landscape architects pay attention to human scale, integrating design with existing site conditions and client needs. They consider ease of maintenance and appropriate plant selection, with special attention to innovative uses of new materials. Contemporary designers seek a better understanding of the complexities of site, region, and community values. The more progressive designers strive for an integration of regional history and culture, landscape as art, and sustainable ecological design. The most successful gardens combine visually exciting composition and unified, harmonious places that are well suited for both wildlife (including invertebrates) and people.

Gardening and landscape design are complex challenges, and each situation is unique. Some people meet the challenge of desert gardening by joining with it—restoring or enhancing what already exists in their adjacent "wild" environment. Others create walls, water features, and lush oasis plantings. Many gardeners prefer a combination of the two: part oasis and part dry, or xeric, landscape.

The "Xeriscape concept" of landscape design, first described by the Denver Water Authority in the 1970s, promotes the benefits of dividing a residential landscape into a series of zones. Typically, the front yard and outer back yard would need little water, blending in with the natural landscape. An intermediate zone in the back yard would contain both low-water-use plants and greener or larger-leaved species transitioning to a "mini-oasis" zone strategically located close to the house. (The term "Xeriscape" refers to a water-conserving landscape. In contrast, a "zeroscape" is a landscape takes the concept of low-maintenance to such an extreme that

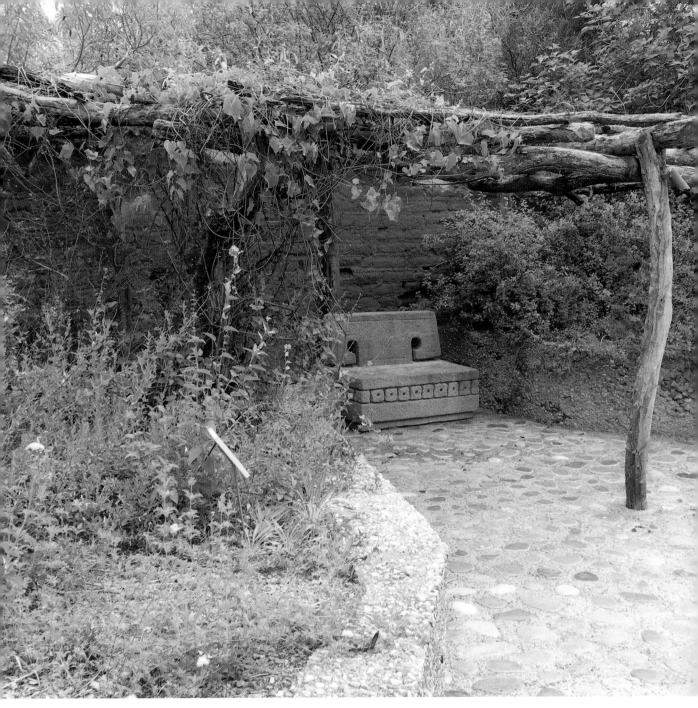

This secluded ramada in one of the Desert Museum's Xeriscape gardens is an inviting place to sit and relax.
PHOTO BY D. LARSON

nothing remains but gravel, and, perhaps, a cactus or two. Such a garden,
though it conserves water and is low-maintenance, usually lacks interest
and beauty.)

The Desert Museum's Garden Designs

The Arizona-Sonora Desert Museum employs many landscape and garden designs so that visitors can see what might be possible at their own homes. Before the 1980s, the Museum displayed only a few dozen species indigenous to the area surrounding Tucson. Few native plants were available from commercial nurseries, and almost no one knew how to grow them. Yet, habitat exhibits like the Riparian Exhibit and the Life Zone Transect required a diversity of plants to accurately represent each biotic community. Furthermore, the point is to showcase native plants in the gardens, to encourage their use in residential and commercial landscapes. So the Museum first collected them from the wild, and then learned how to cultivate and propagate them. Years of trial and error have enabled us to display over twelve hundred species of regional natives.

Plants that thrive in the Sonoran Desert would struggle in other climates.
PHOTO BY M. A. DIMMITT

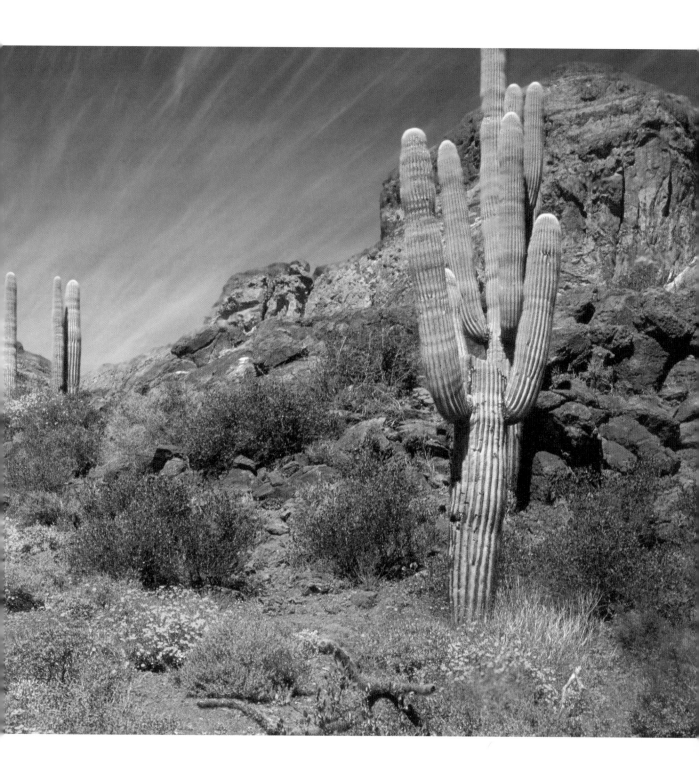

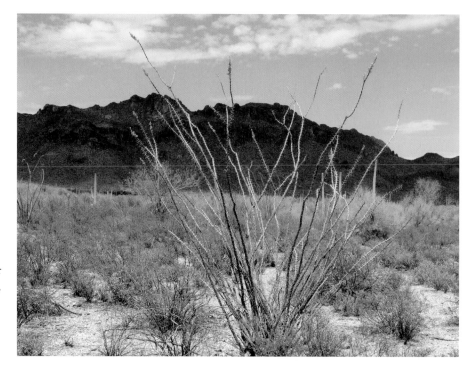

Ocotillo plants drop their leaves during dry periods, but grow new ones within a few days after a rainstorm.

PHOTOS BY D. LARSON

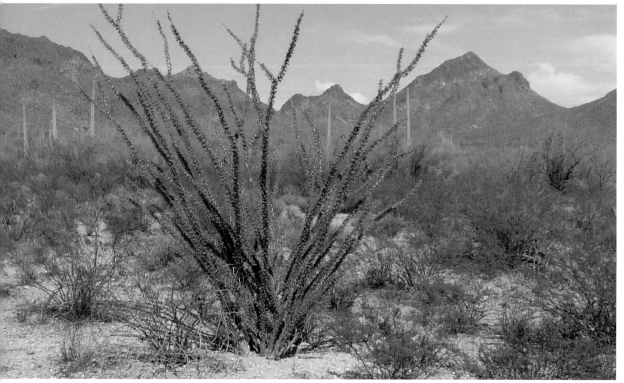

DESERT GARDENS

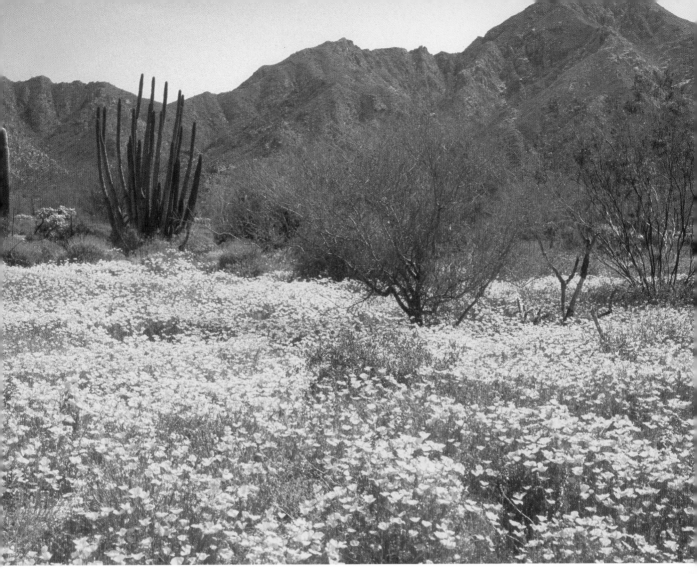

The Desert Museum encourages our desert dwellers and visitors to draw upon the wealth of attractive plants that are adapted to our regional climate. Gardening with plants that are native to the region in which you live increases your chances of success. These plants are already adapted to the weather and soil conditions that they will face on a daily basis. Plants from other regions with a similar climate may adapt well to this region, but be careful to avoid invasive species, which are often sold in local plant nurseries. (See Chapters 15 and 16 for plant choices.) These drylands plants can be divided into three major categories: drought evaders, drought tolerators, and succulents.

Good winter rains can bring spectacular spring wildflower displays around the Desert Museum. PHOTO BY M. A. DIMMITT

Drought Evaders. These are mostly annual wildflowers and a few short-lived perennials. They lie dormant as seeds, sometimes for many years, waiting for the combination of temperature and rainfall conditions that favor their growth and survival. Then they germinate, grow to maturity, flower, and set seed, all within a few months. Some summer annuals, such as devil's claw, will flower within only three weeks after a rain. These super-fast responders are called ephemerals.

Annual wildflowers make up half of the Sonoran Desert's flora, but they appear in great numbers only in wetter-than-average years. A banner wildflower season generally occurs only once a decade, but when it happens the springtime desert is carpeted with all the colors of the spectrum. Poppies, lupines, globe mallow, silverbells, penstemons, desert chicory, verbena, mustards, evening primrose, and phacelias are just a few of the hundreds of species of wildflowers that can occur in a "good year." Wildflower seeds can be sown in your garden or landscape in the fall, and regular irrigation through the winter will ensure a good display nearly every year.

Drought Tolerators. Desert plants use a variety of adaptations to survive periods of drought. Many of the larger trees and shrubs have deep roots that tap enough soil moisture to flower during the spring dry season. Their vegetative growth occurs only during rainy periods, just as annual wildflowers do. Unlike the wildflowers, shrubs and trees do not die when the rain stops; their tissues can survive with very low moisture content. Some, such as palo verde trees and ocotillos, are what is called drought deciduous. They reduce moisture loss by shedding their leaves, and even whole branches, during times of drought.

Small leaves also mitigate drought stress; there are very few large-leaved plants in the desert. Small leaves can radiate enough heat to avoid overheating without the need for evaporative cooling. This is important in the Sonoran Desert, where the hottest months tend to be driest (May and June—the hot, dry stretch before summer monsoon season begins).

Some plants use water-resistant coatings to reduce water loss. The leaves of creosotebush, for example, are covered with a layer of resin. When the stomata are closed, the leaf is nearly waterproof. Jojoba shrubs reduce heat buildup and moisture loss with vertically oriented leaves that present only their thin edges to the sun during the hottest part of the day. The sun shines on the relatively broad, flat surfaces only in the early morning and late afternoon.

Saguaros, like many cacti, store water within their enlarged stems. PHOTO BY M. A. DIMMITT

Succulents. A plant that stores water in its roots, stems, or leaves is called a succulent. The most recognizable succulents are the cacti, many of which use specialized stem tissues to hold large quantities of water. Mature saguaros can absorb up to a ton of water from a single rainfall by expanding their pleated ribs to full capacity. They then use the stored

water during dry periods or droughts, often shriveling noticeably by the end of a dry season.

Agaves are examples of leaf succulents. Their whorls of thick, fleshy leaves often have a V-shaped trough to help direct rainfall to the roots. A familiar root succulent is the queen-of-the-night cactus. It has thin, nondescript stems that look like dead branches. However, its flower and aroma are outstanding, and its tuberous root can be as large as a basketball. It is a favorite food of javelinas.

Although succulent plants in a landscape need little or no maintenance and draw instant attention, they should be used sparingly. Too many accent plants, as they are often called, cause the landscape to appear busy, as the viewer's eye darts from one to another. Before selecting plants for your southwestern garden, take the time to learn the relevant characterics of every species you are considering: the type of plant and its mature size, to allow room for full growth; watering needs according to season, temperature, and rainfall; seasonal flowering or foliage habits; hardiness to cold or drought; rate of growth; and risk of toxicity for pets or children.

Opposite — The spectacular flower of the queen-of-the-night cactus is night-blooming, fragrant, and pollinated by moths. PHOTO BY JOHN P. SCHAEFER

Agaves are leaf-succulent plants common in the Sonoran Desert (*Agave cerulata dentiens*). PHOTO BY M. A. DIMMITT

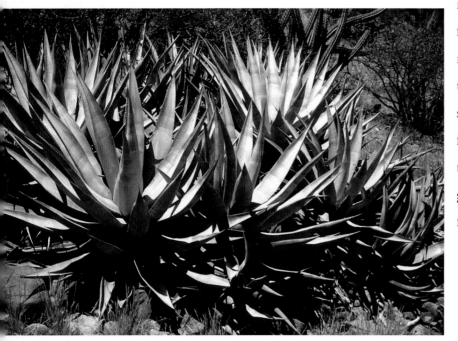

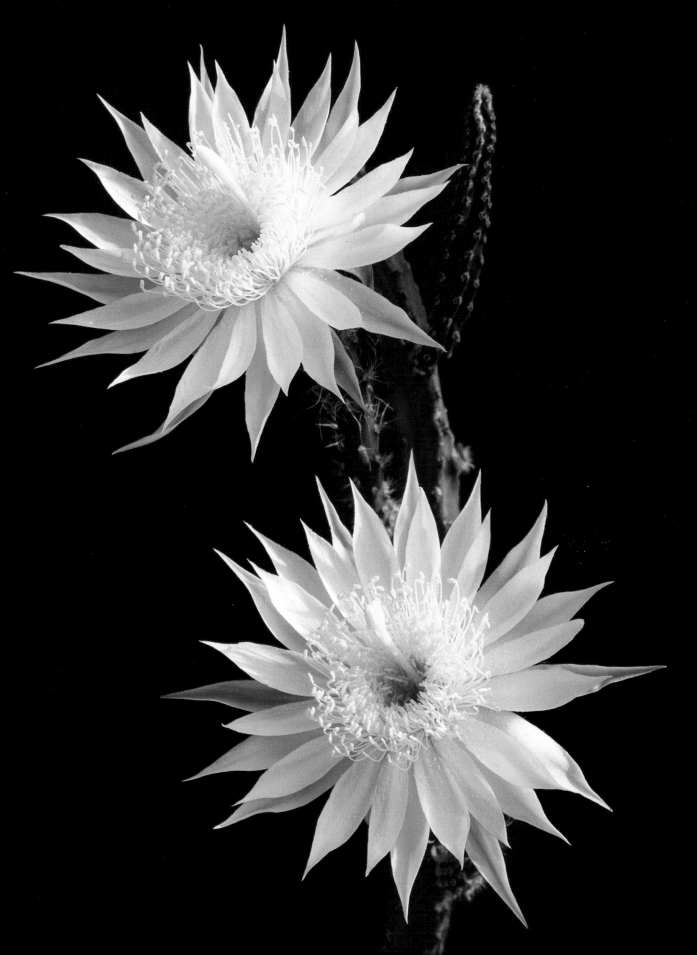

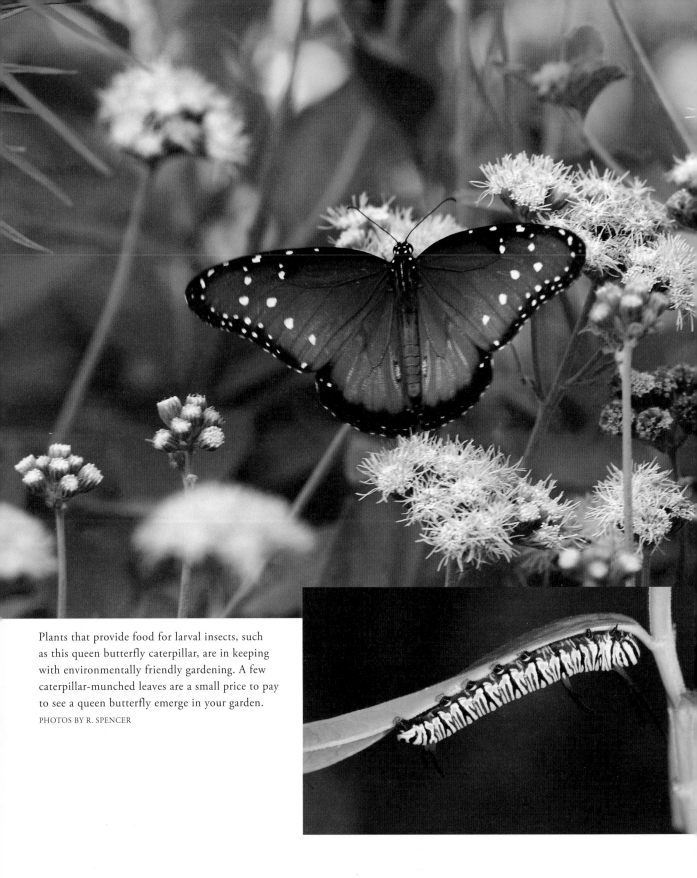

Plants that provide food for larval insects, such as this queen butterfly caterpillar, are in keeping with environmentally friendly gardening. A few caterpillar-munched leaves are a small price to pay to see a queen butterfly emerge in your garden.

PHOTOS BY R. SPENCER

Wildlife in the Southwest Garden

From the perspective of insects, birds, and mammals, your garden plants are just food, water, or nesting materials. Since these "critters" have ecological roles, the Desert Museum conducts minimal "pest" control; eradication is not our goal.

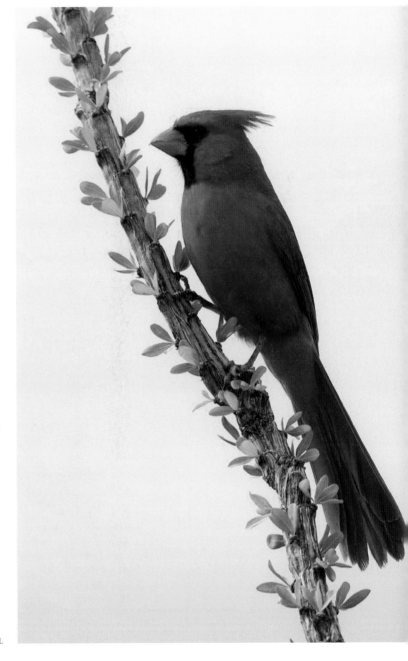

If you find that some form of wildlife has become a nuisance in your landscape, consider the ecological big picture before jumping ahead to plans for extermination. What role does the animal or insect play in nature? Would its absence affect the balance of other wildlife in the immediate environment? Is there a more environmentally friendly way to solve the problem or alter that animal's behavior? Life is more fulfilling when we find ways to live with nature rather than constantly fight it.

Your garden can be beneficial to wildlife such as this male cardinal. PHOTO BY A. KOZIOL

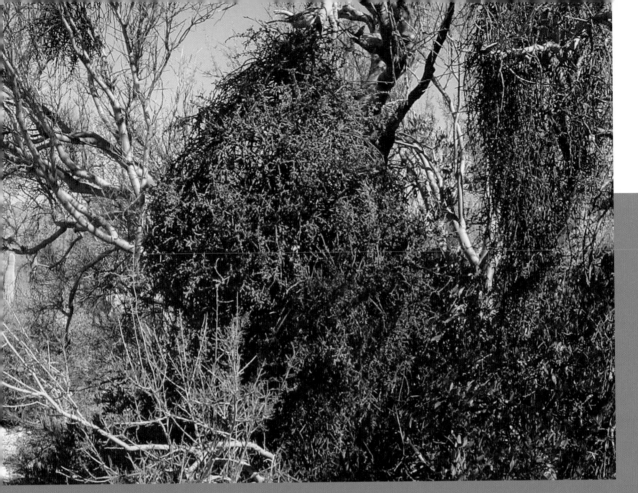

Gardening the Desert Museum Way

BY GEORGE M. MONTGOMERY

Newcomers to the Desert Southwest notice the difference immediately—gardening in the desert is not like gardening in any other climate. Gardeners here must come to understand local climate patterns, the mix of different soil types, and which plant species are likely to survive summer temperature extremes and occasional winter frosts. Gardening at the Desert Museum is even more nontraditional because of the Museum's mission and vision. Our institutional

focus on the greater Sonoran Desert region compels us to understand and exhibit plants from our part of the globe. But because the Sonoran Desert region (which includes embedded, non-desert habitats such as grasslands and mountains) is home to about five thousand species of plants, there are a huge variety of options with which to experiment.

With so many species to choose from, we must filter our choices. We first decide the nature of the ecological interpretation for a given exhibit and the integration of the chosen plants with the exhibit animals and geological landscape. Then we select plants that we can use to our advantage to interpret a biome and provide strong education and conservation messages. For example, to maintain a natural look in many areas we leave the desert mistletoe on our plants; this also attracts phainopeplas (*Phainopepla nitens*), which the birdwatchers appreciate. Also, instead of using pesticides to maintain perfect specimens, the Museum tolerates "damaged" plants and uses them to interpret the relationships between plants and animals.

Phainopeplas are so dependent on the berries of desert mistletoe that they time breeding for the early spring to coincide with the peak of the berry crop and the first insect hatches of the year. PHOTO BY M. A. DIMMITT

Opposite — Desert mistletoe grows in many Sonoran Desert trees, providing fruit for native birds. PHOTO BY M. A. DIMMITT

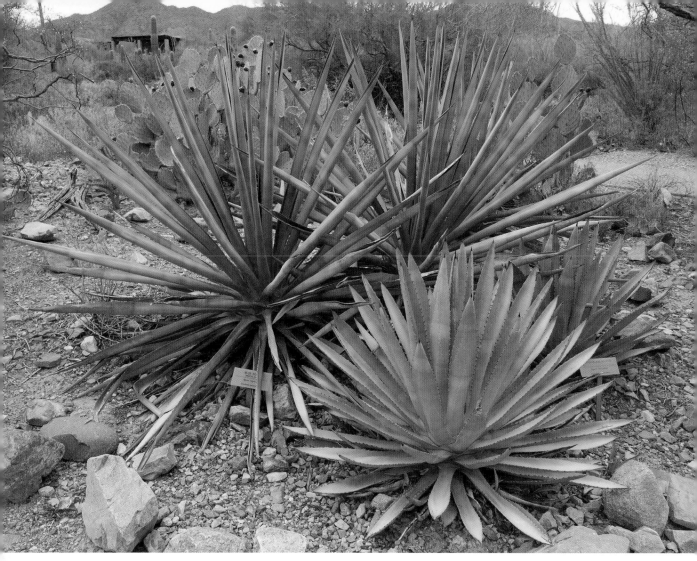

The Agave Garden is one of the Desert Museum's most popular conventional gardens.

PHOTO BY J. BROOME

Natural and Conventional Gardens

Horticulture at the Desert Museum falls into two general categories: *conventional* and *natural*. The Cactus, Agave, Pollination, Convergent Evolution, and Desert Gardens are all *conventional*; they are contrived, human influenced and maintained, and have formal pathways designed for the optimum viewing of plants. But even our conventional gardens differ from most traditional gardens in temperate North America because we recognize a prominent feature of the desert—the open spaces between plants with resulting bare ground, and the informal, random spacing of the plants.

Many of the most popular exhibits at the Museum are *natural* gardens. The goal in these gardens is to represent our region's native landscapes and vegetation as accurately as possible. It is in these gardens—the Desert Loop Trail, Mountain Woodlands, Desert Grasslands, Tropical Deciduous Forest, and others—that we focus on concealing our horticultural efforts. During the initial design phase of these gardens, we use artificial rockwork and careful lines-of-sight to create visual barriers to manmade elements. The interior of the Desert Grasslands, for example, is a grass-covered hillside that immerses the visitor in the habitat while it also excludes the view of desertscrub vegetation just beyond.

Creating and maintaining a natural garden can be both challenging and easy. One big challenge is to refrain from doing what may have been learned from books or from visits to traditional gardens! Meticulous care for these gardens is not needed, but they still require attention. Seeing

Left — Well-developed growth in the Grasslands Exhibit adds to the immersion experience. PHOTO BY DESERT MUSEUM
Right — Soaptree yuccas are typical of grassland habitat in the Sonoran Desert. PHOTO BY D. HANCOCKS

the plants in their native habitat allows one to become familiar with spacing and size, types of soil, light, and water requirements, as well as other subtleties that lead to successful desert horticulture. The inspired-by-nature garden is simultaneously a wildlife habitat, a less-than-tidy assemblage of plants, and an exercise in natural history. We work hard to keep our gardens looking natural, constantly fighting the impact of foot traffic by visitors, altered rain runoff patterns due to paths and buildings, and succession by weedy invasive species.

The Museum's Standards of Care

All of the landscaped areas at the Desert Museum—garden, exhibit, pathside, or buildingscape—have prescribed care standards. The Pollination and Desert Gardens, for example, are maintained to an "excellent" standard, which requires there be no dead or poorly performing plants, so all specimens are kept at peak performance. These well-tended gardens require the most time and attention.

The second prescribed care standard—at the other end of the spectrum—are the "natural" gardens and areas. Plants in these gardens may have non-hazardous broken branches, spent flowers, and dying mistletoe because these exhibits portray natural habitats, with the same kinds of views one might see when hiking in the Sky Islands or the Tucson Mountains, or driving along the Sonoita Highway.

The third care standard is "enhanced natural." In locations that are not specific or interpreted exhibit areas, the visitor's view and appreciation of desertscape can be enhanced with compositions of mass flowerings or

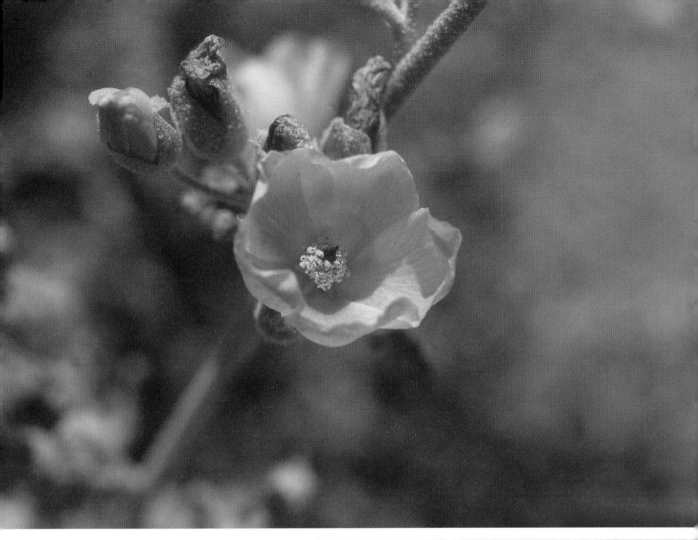

similar features. The desert land-scape just beyond the Ironwood Restaurant's outdoor terraces, for example, has densely planted fairy dusters and mallows that provide visual delight for diners.

Enhanced natural gardens, especially those enhanced with wildflowers, as can be seen in these two varieties of desert mallow (*above* and *right*), are often planted around buildings at the Desert Museum.
PHOTOS BY J. BROOME

A Year in Horticulture at the Desert Museum

The Sonoran Desert has five seasons, and they dictate life at the Museum. The hot pre-summer drought, when air temperatures routinely exceed 100 degrees Fahrenheit, is a time of beauty distinguished by the flowering of saguaro, organ pipe, and the queen of the night. It's also a time of stress for plants in our gardens that are native to higher elevations or latitudes, which dictates increased irrigation to many gardens and temporary shading for some plants.

Then comes the summer monsoon season, from late June to early September, when 4 to 7 inches of greatly anticipated rainfall comes to southern Arizona. Fall is brief in the Sonoran Desert (October and November), as is winter (December and January) when the frosts finally come. In the fall, along with pruning after the monsoon season growth, Museum horticulturists carefully organize materials for frost protection because we get up to a dozen frosts per winter. The majority of plants are well-adapted to mild freezes, but we use Styrofoam cups to cover sensitive cactus tips, while feed bags and commercial frost cloth work well to cover others, especially those from the more tropical regions of southern Sonora. Spring is joyous in this desert, especially if the winter rains have been good and the wildflower shows become exuberant.

Until the mid-1980s, plants at the Museum were hand watered. Construction of the Mountain Woodlands Exhibit brought the first opportunity to install automated irrigation. The twenty-two valves that shunt water to that exhibit utilize an electronic controller that has performed well for a quarter of a century. Since then, another nineteen electronic controllers have been installed, delivering water to over two-

Newly planted cacti often need to be covered with a light shade cloth in the summer. PHOTO BY G. M. MONTGOMERY

hundred-and-fifty automated valves through many miles of irrigation pipes and tubing. Maintaining this hardware is part of gardening at the Museum. A significant portion of irrigation is provided by reclaimed water, especially from the beaver and otter ponds in the Riparian Exhibit where the water is changed on a regular basis for animal health.

The extent and diversity of our gardens are a challenge, a pleasure, and ongoing education for our horticulturalists. We hope our visitors find only pleasure and education!

Container Gardening

GEORGE M. MONTGOMERY

With more than twenty acres of exhibit space and thousands of landscape plants already in place, why grow more in pots? Accenting a paved space, softening a hard wall, rotating specimens in dimly lit locations, frustrating nibbling pests, maintaining portable live plants for docent interpretation, and providing temporary displays are some of the reasons we use plants in containers at the Desert Museum.

Our Museum horticulturists care for more than one hundred and fifty containers throughout the public grounds and in buildings. A few are on automated drip systems, but most are hand watered as needed. Container gardening allows for periodic displays of color when a cactus plant showcases its ephemeral flowers, or for exhibiting a tropical specimen that lives in a greenhouse during the winter.

The barrel cactus, *Ferocactus johnstonianus*, is endemic to Ángel de la Guarda Island in the Gulf of California; here it sets off the corner of a shade ramada. PHOTO BY G. M. MONTGOMERY

Opposite — This large potted rock fig in a concrete wok-pot softens a massive stone wall at the Desert Museum's Ironwood Terraces Restaurant. PHOTO BY G. M. MONTGOMERY

GUEST ESSAY

GREG CORMAN

Trips to the Arizona-Sonora Desert Museum still make me smile when I think about my first experience there and in the surrounding Tucson Mountain Park. I was a young visitor from the Midwest and my knowledge of Tucson and its environment was limited to what I'd gleaned from *National Geographic* and other magazines, although I didn't really expect the sun to be wearing a cowboy hat as the ads seemed to suggest. My motive was to find a new home where car engines didn't freeze solid and where temperatures only went below zero on the Centigrade scale. With a little more research I might have known better than to stuff my pockets full of "souvenir" prickly pear fruits. These vegetable hornet nests riddled my trousers with spines and taught me a painful lesson, which included an introduction to the word "glochid."

The pain was short-lived and gave way to fascination during my undergraduate years at the University of Arizona. Biology and ecology classes helped me understand the Sonoran Desert theoretically, while field trips with fellow students were more practical. Our syllabi included tipping rocks in search of scorpions, prodding the gooey remains of dead barrel cactus, breathing through cupped hands full of creosote leaves, and listening to the orchestra of wind as it played the needles of saguaro cacti. The Arizona-Sonora Desert Museum was a favorite destination for these excursions, and it didn't take long to see that it was remarkably different from other zoos, arboreta, or parks I'd experienced.

This bee habitat sculpture was made by Greg Corman of Gardening Insights Inc.
PHOTO BY G. CORMAN

The difference is one I still appreciate. The Desert Museum celebrates what is right here. Literally right here. Instead of showcasing the exotic, it revels in the diversity, the wonders, and the drama of its surrounding landscape. It encourages us to observe, to explore, and to connect with the desert and its plant and animal citizenry; to love it for what it is, not for what it becomes with green lawns, citrus trees, and golf courses. The Museum's programs, displays, and outreach provide insight into one of the most amazing places on the planet, a place of stunning beauty and ecological significance that we are fortunate to have in our backyards.

Now after twenty years of living in Tucson and working as a landscape designer, I still visit the Museum for inspiration. Within its bounds I find myriad ideas for selecting and composing native plants for dramatic, desert-friendly gardens. I find information for nurturing local wildlife

with habitat plantings and shelter. I see creative uses of desert materials in the patios, shelters, and other amenities. And I never tire of visiting the hummingbird enclosure for close-up views of its little feathered jewels. The Museum is incomparable as a place to learn and explore for casual visitors and professionals alike. This is especially important because so many people move to southern Arizona from other parts of the country and need help understanding their strange new home.

I am also grateful for the Museum's staff of world-class naturalists who are gracious colleagues and knowledgeable, accessible resources for nature related inquiries. Their expertise ripples across the Southwest and northern Mexico through their work and that of the volunteers they train. Because of the Desert Museum, I do not think it a stretch to say that Tucson has the highest concentration of native plant and animal experts of any city in the United States.

Opposite — Purple slipper flowers (*Pedilanthus macrocarpus*) add unusual architecture and color to desert gardens.
PHOTO BY K. DUFFEK

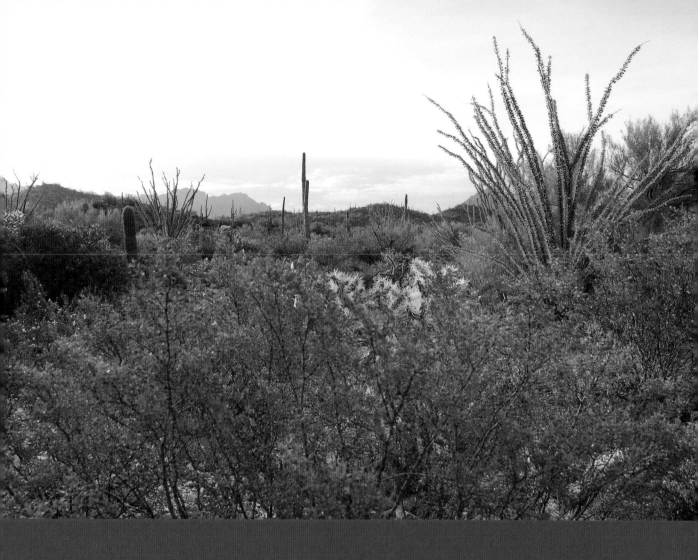

THE DESERT LOOP TRAIL

BY DANIEL ARMENTA

The Sonoran Desert region, including embedded, higher-elevation grasslands and mountain ranges, encompasses approximately 100,000 square miles and is home to about five thousand plant species; the low elevation desert flora alone includes over two thousand species. The landscape varies widely, from the seemingly endless flats of creosote bushes in southwestern Arizona to the bizarre cardón, boojum,

and elephant tree terrain of the Vizcaino region of the Baja California peninsula. Scientists have defined six distinct subdivisions of the Sonoran Desert (see Chapter 1), and the Desert Museum is situated within the Arizona Uplands subdivision. The Desert Loop Trail provides access to a series of exhibits that showcase this incredibly rich habitat.

On the Desert Loop Trail, visitors stroll across a bajada that overlooks a view to the Mexican border 60 miles to the south. Javelina and coyote roam freely in large enclosures. This is also the venue for the Museum's famous Raptor Free Flight Program, a unique experience created by raptor specialist Jim Dawson, where many species of taloned predatory birds fly free to the delight of our visitors. The vistas here are so vast that visitors cannot tell where the Museum "ends" and the rest of the Sonoran Desert begins.

Planning for the Desert Loop Trail began in the early 1990s, and, because of its size and complexity, required many workshops with staff, local scientists, volunteers, and the public. The exhibit was designed by the architectural firm Jones and Jones in Seattle. Former Museum Design and Planning Director Ken Stockton oversaw the construction and made many modifications to the plan while the project was underway. The Botany Department was immersed in the planning and construction for several years to assure that damage to the natural landscape was minimized (or revegetated as needed) and that the floristic exhibitry lived up to its potential.

Opposite — The dense green in the Arizona Upland causes many to question whether it is a desert at all.
PHOTO BY D. ARMENTA

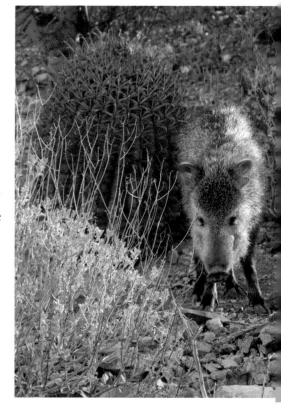

Javelina enjoy the landscape as much as the visitors. PHOTO BY D. ARMENTA

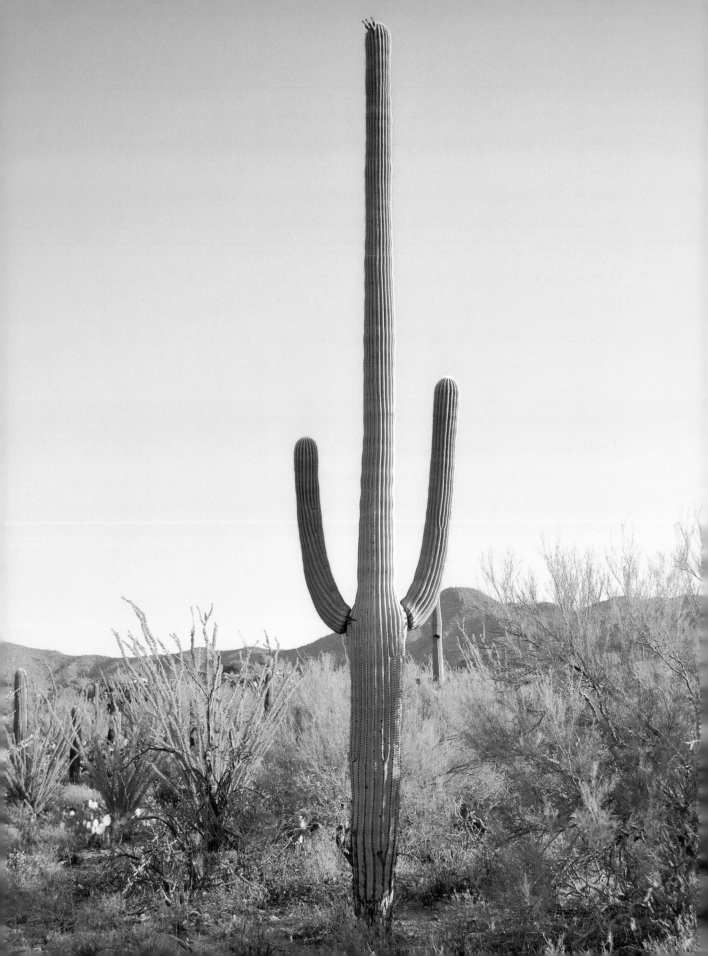

Three natural stone bridges were built to span drainages and provide a shady shelter for the javelina. It took about two years to complete the actual trail, which set the stage for the rest of the exhibit—the details of additional landscaping and the construction of the animal enclosures. As animals were introduced into their enclosures, plants were added to replace those that perished under paw, hoof, or jaws. Sometimes it is necessary to move or replace plants that are creating too much of a visual barrier for visitors. Working inside animal enclosures can be challenging!

We try to keep the plants limited to species that would occur in the animal's natural habitat so that the exhibit is completely realistic. Care is taken to make sure there are no plants in the exhibit that may be toxic or harmful in any way. We consult with the Museum's animal keepers to choose plants that are useful to the animals as food or shelter. Because keeping animals in enclosures, even if the enclosures are large, limits their range, plants within the enclosures take more of a beating than they would in the wild.

This is a dynamic sort of gardening, with new challenges popping up all the time! The Desert Loop Trail is one of the cornerstones of the Museum, and it is constantly evolving.

Opposite — A saguaro guards the Desert Loop Trail. PHOTO BY D. ARMENTA

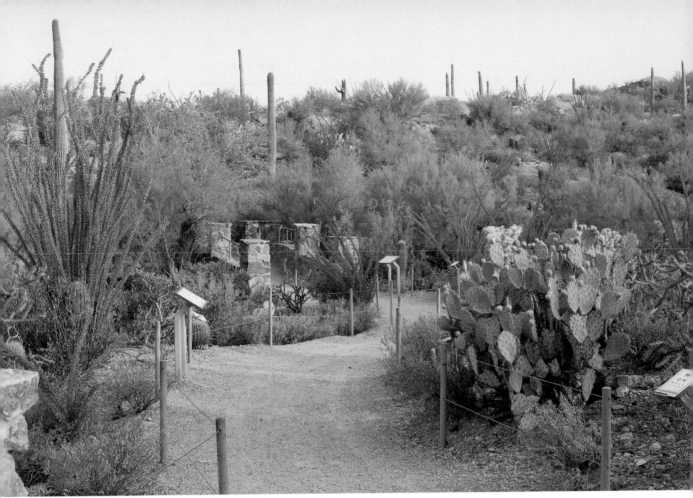

Top — Signs throughout the Desert Loop Trail interpret the natural history of the Arizona Upland habitat. PHOTO BY D. ARMENTA. *Above* — This is one of three natural stone bridges on the Desert Loop Trail that pass over small drainages and provide shade and shelter for javelina. PHOTO BY D. ARMENTA. *Right* — Fishhook barrel cacti are common in the Arizona Upland habitat. PHOTO BY D. ARMENTA

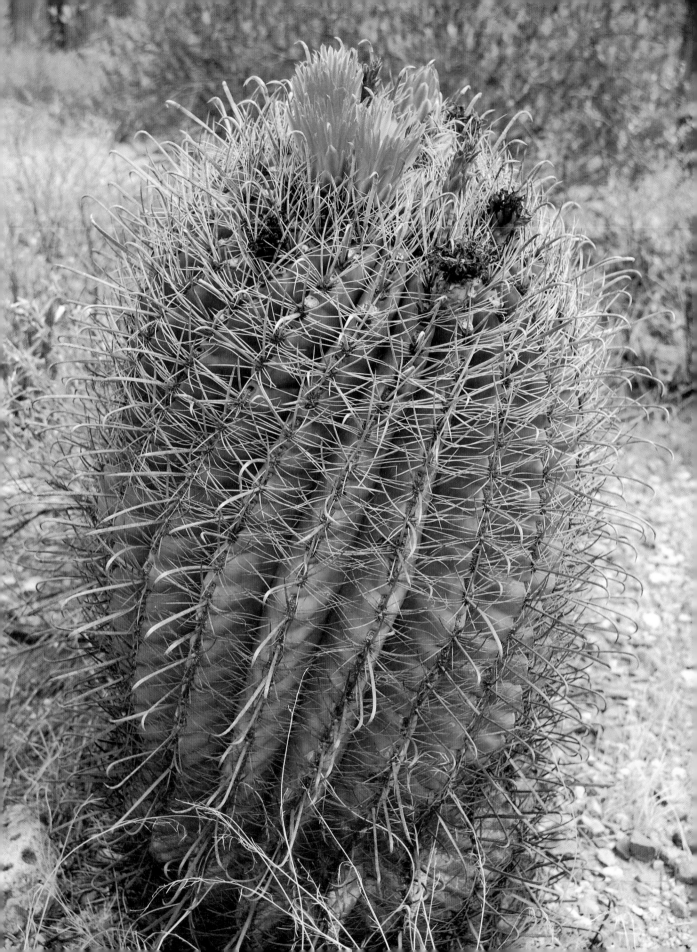

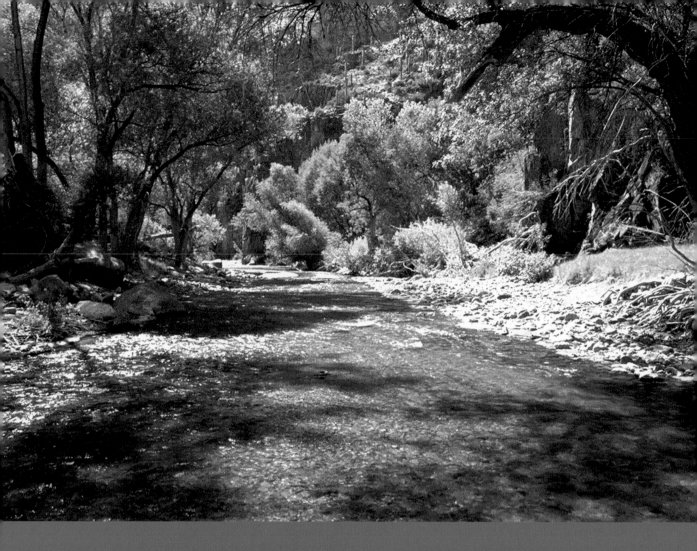

Riparian Exhibit Gardens

BY DOUG LARSON

The sound of running water, the rustle of cottonwood leaves in the breeze, otters engaged in underwater acrobatics, and the sounds and smells of a living wetland are just a few of the sensations that visitors experience in the gardens of the Riparian Exhibit at the Desert Museum. Bird watchers gravitate to this exhibit, hoping to spot migrating warblers, nesting orioles, or a rare yellow grosbeak.

With their exceptional plant and animal diversity, riparian habitats are lush biotic communities associated with perennial rivers and springs, but it is increasingly rare to find a year-round source of water in the desert. Most of the rivers, or *arroyos*, in the Southwest are dry for most of the year largely due to excessive use by an expanding human population. In the Sonoran Desert, most run aboveground only episodically, during the summer monsoon season, although in certain stretches along these otherwise dry rivers, bedrock substrate forces the river aboveground, creating springs and riparian habitats.

Although there are "dry rivers" that flow underground as shallow aquifers, even these are being lost as human demand for water grows. Water is such a valuable commodity in the desert that riparian habitats are highly attractive to many species of plants, which in turn creates a very desirable environment for a wide array of animals. The migration routes of many types of animals follow these river systems.

Opposite — Southern Arizona's rare, natural riparian habitats are jewels of the desert.
PHOTO BY M. A. DIMMITT

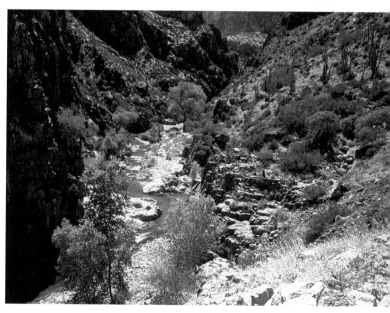

Less than a century ago, riparian areas in the Sonoran Desert were much more common than they are today. Due to the clearing of many *bosques* (Spanish for woodlands) for agriculture and pasture, water diversion, and the lowering of groundwater tables by pumping

Flowing water and riparian corridors in the desert are rare but welcome sights, which is why the Museum created the Riparian Exhibit.
PHOTO BY M. A. DIMMITT

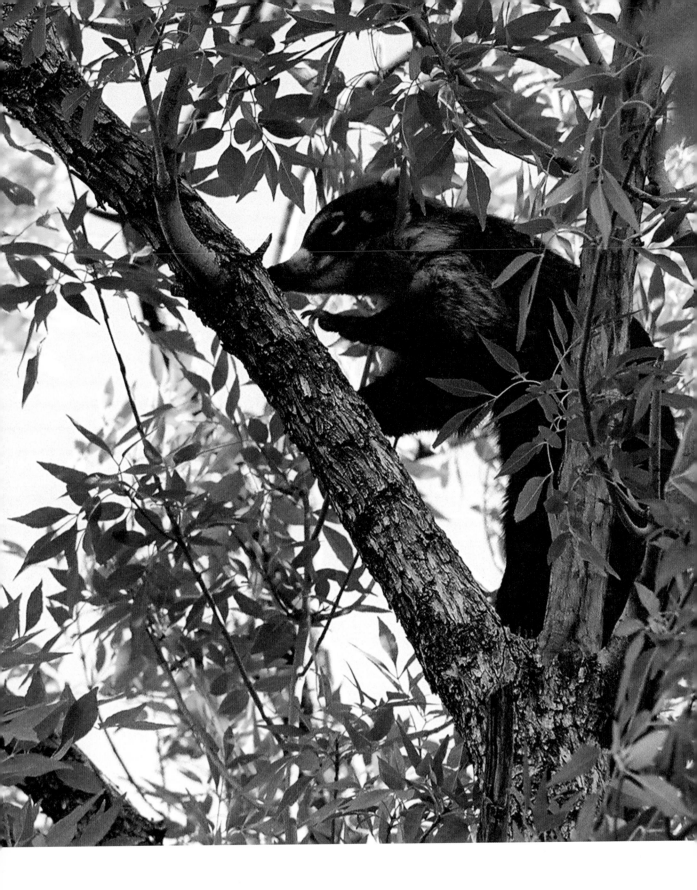

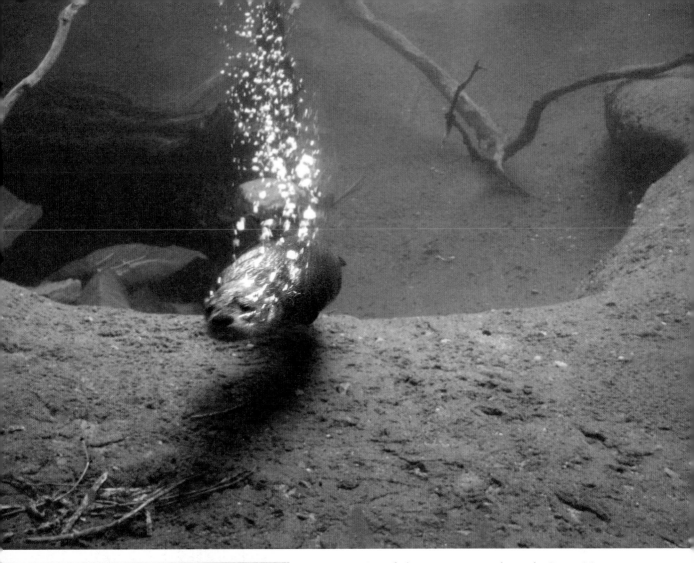

Opposite — Coati frolic in a riparian garden at the Desert Museum.
PHOTO BY K. DUFFEK

Above — A river otter glides effortlessly throughout his watery enclosure in the Riparian Exhibit at the Desert Museum. PHOTO BY E. RAKESTRAW

Left — This blue heron sculpture is found in the stream above the Desert Museum's beaver pond. PHOTO BY E. RAKESTRAW

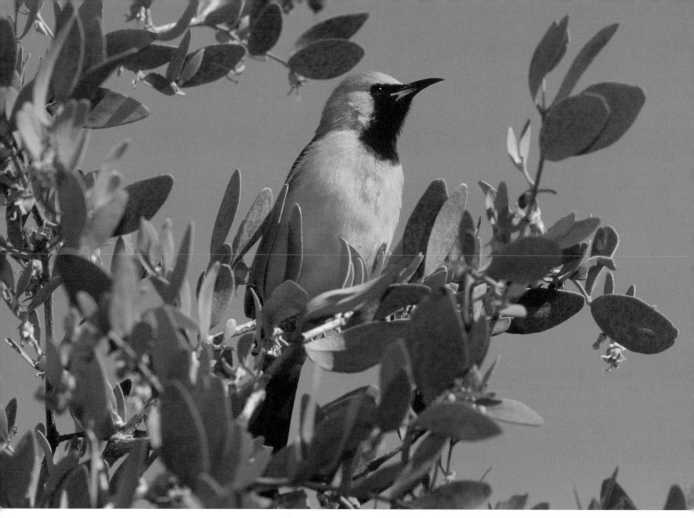

A great variety of colorful birds, including this hooded oriole, frequent the Riparian Exhibit at the Desert Museum.
PHOTO BY P. BERQUIST

overdraft, only 5 percent of riparian river systems in this region still exist today. Conservation groups and governmental agencies have now made it a priority to preserve and protect these valuable natural resource areas.

The Riparian Exhibit at the Desert Museum was first opened in the late 1960s with the construction of the river otter pond, and then the adjacent beaver pond, each including underwater viewing. The otter and beaver enclosures were modeled after the Santa Cruz River (west of Tucson), as it would have appeared in the late 1880s.

The "big five" desert riparian tree species create the gallery forest for

this habitat: Fremont cottonwood, Goodding willow, Arizona sycamore, velvet ash, and Arizona walnut. Given that a mature cottonwood can transpire over 500 gallons of water daily, and can steal water from the roots of adjacent trees, only a few (male) cottonwoods are allowed to grow in this exhibit. The newer coati exhibit, in the same vicinity, was modeled after a favorite Southern Arizona birding site, Sycamore Canyon, in the Pajarito Mountains near the Arizona-Sonora border. The Museum's Riparian Exhibit also has a wetland with aquatic plants and living insects. This "bug pond" offers an up-close view of the insect life that inhabits this biotic community.

Families often linger in these riparian gardens, raising their eyes in search of coatis among the branches of a velvet ash tree, or peering into the beaver pond to see if a beaver is out for a swim with the large, native fish. In spring, plant lovers will find the spectacular bright red, tubular flowers of the western coral bean. And everyone wrinkles their noses when the willow groundsel shrubs bloom in late winter; they smell like stinky socks and are pollinated by flies. Fortunately, their bright green leaves and lemon yellow flowers appear at a time when many surrounding plants are dormant, making up for their disagreeable odor.

Other plants in this exhibit include velvet mesquite, Mexican blue oak, Mexican elder, desert willow, Arizona rosewood, hopbush, and desert honeysuckle.

The willow groundsel is known as the "stinky socks plant" among Botany Department staff, for reasons that are obvious during its blooming season. PHOTO BY M. A. DIMMITT

GUEST ESSAY

Scott Calhoun

have a picture of myself taken on my first visit to the Arizona-Sonora Desert Museum in 1972. I'm six years old, and I'm holding my Dad's hand and standing in front of an ocotillo and saguaro. I'm wearing a stars and stripes tank top, and my Dad is wearing a white Mexican shirt with blue embroidery and some cut-off jean shorts that I'm quite sure were never in style. But what I remember most from this first visit was leaning on a sun-warmed wall and watching collared lizards dart about the rocks. As much as I loved that first visit, I had no idea back then how important the Arizona-Sonora Desert Museum would become in my adult professional life.

As it turned out, the lizards and other animal attractions became less of a draw for me and on return visits I rarely visited the zoological exhibits . . . I was there for the plants! After passing through the wide entrance portal at the Museum, one can turn to the right or left. Right will take you mostly toward animal and reptile exhibits; left takes you toward the more plant-focused sections of the museum. I nearly always take a hard left!

Although I grew up hiking in the Superstition Mountains, I had never thought about how the desert could be reconstructed and reinterpreted in gardens—even home gardens—until I began visiting the Desert Museum. When I saw the intricate and bold gardens surrounding the Ironwood Terraces Restaurant and Gallery, it ignited a passion in me to make gardens like this all over arid Arizona. I moved to Tucson, started a garden design business, and began writing books about desert plants.

As a resident and professional plantsman, visits to the Museum became part of my routine and education as a desert dweller. I watched the pollination garden being built, and I photographed *Agave pelona* in the new agave garden. I visited the cactus garden in the summer to see Sonoran fire barrel cactus in bloom and returned in the fall to watch the seedheads of blue grama sway in the wind in the Desert Grassland Exhibit. As a result of decades of talented horticulturists crisscrossing Sonora, Baja, and Arizona in search of interesting plants, there was always something new to see.

Although my visits were primarily about plants, animals sometimes literally entered the picture. Once, as I was photographing a group of Parry agave beneath a western soapberry tree, a jet-black Sonoran king

snake slithered into the frame right over the marginal spines of the agave. While photographing tropical sage (*Salvia coccinea*), hummingbirds zipped in and out of my photos, sometimes performing startling dives around my head. In the pollinator garden, I once spent several hours photographing queen butterflies hanging from the puff-ball blossoms of *Acacia angustissima*. I began to see that the bulk of the wildlife within the Museum's boundaries were running, flying, and slithering free—guests from the desert that appeared in the gardens!

In addition to seeing new plants, I used the Museum's gardens for design inspiration. Where some public gardens, particularly cactus gardens, would use a plant singly, the Desert Museum corralled several plants of the same species together to create a more dramatic effect. From these gardens, I learned the value of massing plants, using chunky rock mulches, and planting narrow plants in narrow spaces. I considered the horticulturists at the Museum geniuses for their work creating strong little garden areas brimming with desert plants. Many of these ideas were easily translated to home gardens. Unlike old-fashioned gardens filled with thirsty exotics that recalled lace doilies and the rattling of teacups, the gardens at the Desert Museum were bold and contemporary and tended to gravitate toward, rather than shy away from, spiny plants. And those spiny plants were not used one at a time but in swathes.

Beyond spiny plants, the gardens at the Museum also taught me that small and subtle touches add an extra layer of depth to a garden. When walking around the Museum's gardens, I often wondered what was artifice and what was a natural occurrence. Did the gardeners plant that desert rose-mallow under the foothills palo verde so it would weave its way through the palo verde branches and bloom so wonderfully? Was the little

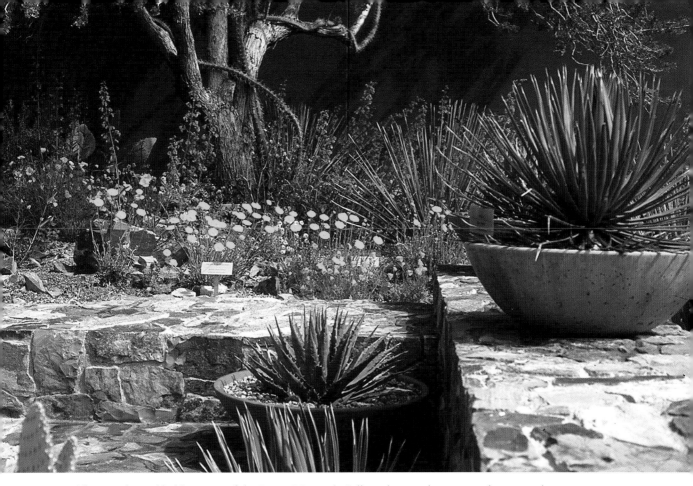

The complex and bold textures of the Desert Museum's Gallery plantings have inspired many gardeners.
PHOTO BY M. A. DIMMITT

twining snapdragon vine growing from a crack in the pavement and then climbing toward the sky like a halo in the leaves of a soaptree yucca the work of some horticultural magician or just a happy accident? These were exactly the sorts of little mysteries and questions that I thought every garden should have.

Ultimately, the gardens at the Desert Museum remind me why I design gardens. They are enriched with regional plants, are home to scads of wildlife, and have enough panache to get you energized to build your own desert garden.

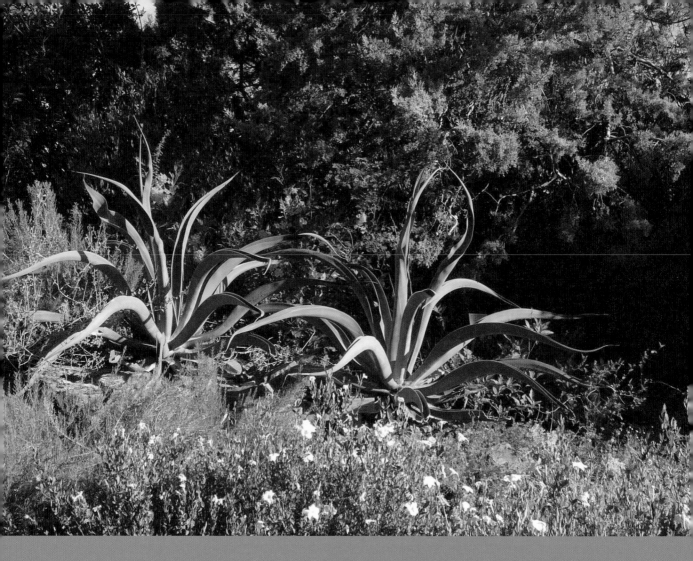

The Desert Garden

BY GEORGE M. MONTGOMERY
AND KIM DUFFEK

The aptly named Desert Garden is one of the most inviting gardens at the Desert Museum, filled with shady, cool niches and colorful plantings. It also serves as a resource for the community, demonstrating appropriate plants and hardscape materials for gardening and landscaping at home in the Southwest.

Originally conceived in 1958 as the "Desert Museum-Sunset Magazine Demonstration Desert Garden," the exhibit was installed in three phases ending in 1971. Since then, landscape styles, available plant materials, and the garden itself have continued to evolve. But the overarching characteristic remains unchanged: the casual atmosphere typical of southwestern gardens.

Very few native plants were in widespread use in the 1960s and 1970s because few were commercially available. The distinctly regional flora

Opposite — The entrance to the Desert Garden is punctuated by octopus agaves. PHOTO BY K. DUFFEK

that is so characteristic of home gardens in Southern Arizona today (a characteristic largely absent in other areas) has been profoundly influenced by the Museum's Desert Garden over the past four decades.

The first phase of the Desert Garden that opened in 1963 was constructed of concrete and stone. The concrete ramada providing shade is an abstraction of a mantling quail with its wings arcing downward to protect its chicks. A massive rock wall made of dark chocolaty-colored boulders from the Amole Arkose formation of the Tucson Mountains integrates into the ramada. A seep in the wall trickles into a reflection pool

Prairie zinnia and Baja California ruellia are good drought-tolerant choices for the Museum and for your home garden. PHOTO BY K. DUFFEK

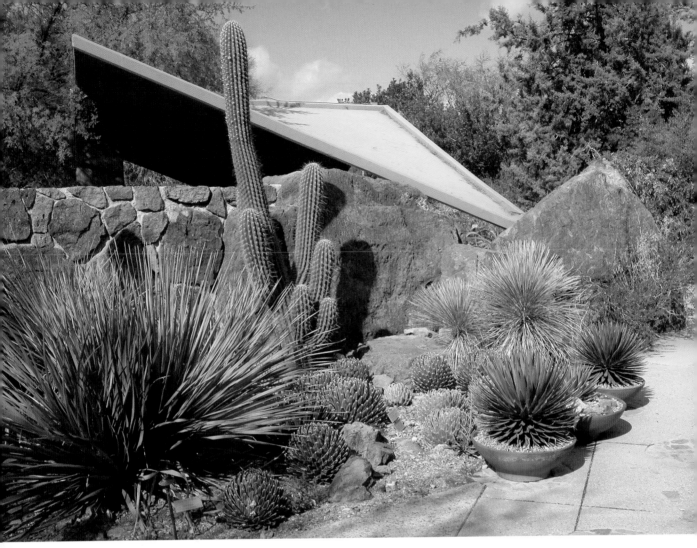

A pitched concrete ramada and massive rock wall create a striking contrast against towering trees and blue skies, as can be seen from both in- and outside the Garden. PHOTO FROM OUTSIDE THE GARDEN BY J. BROOME

planted with Sonoran spider lilies. The planting beds are lush with large trees and colorful flowering plants, most of which are native to the southwestern United States and northwestern Mexico, the Desert Museum's area of interpretation. Succulent plants such as agaves and cacti provide strong accents in the composition.

The garden's hardscape, or structural material, is as varied as the plantings, providing home gardeners with a wealth of ideas. Walkways of concrete, river rock in exposed aggregate, or brick wend through the landscape. Walls and planters are stone, brick, burnt adobe, or mud adobe.

The second phase, or mid-garden, was created in 1969, and features a rectilinear hardscape of red brick and burnt adobe. An ironwood tree and a soapberry tree provide shade. The walk-level plantings reflect hues of white, gray, purple, and blue to create a cool ambiance, while masses of *Huachuca agave* punctuate the beds. A raised planter displays a sunny medley of desert spoons, grasses, and groundcovers with flowers of yellow and purple. This mid-garden is frequented by a diversity of wild reptiles, birds, and butterflies.

The third phase, or lower garden, dedicated in 1971, opens onto a patio of river rock aggregate set in concrete, surrounding a hexagonal concrete and tile fountain. An eroded adobe wall encloses the space on half its perimeter. Exposed aggregate retaining walls support raised beds planted with red, white, and purple flowers. Benches and pots carved out of volcanic tuff have a welcoming, indigenous feel. Nestled in a niche against the adobe wall and under a rustic structure made of mesquite, these benches encourage visitors to sit and delight in the multitude of hardscape and botanical textures, and observe the visiting wildlife.

Top — Sonoran spider lilies add beauty to any garden. PHOTO BY K. DUFFEK

Above — A burnt adobe wall is a good hardscape choice in a desert garden. PHOTO BY K. DUFFEK

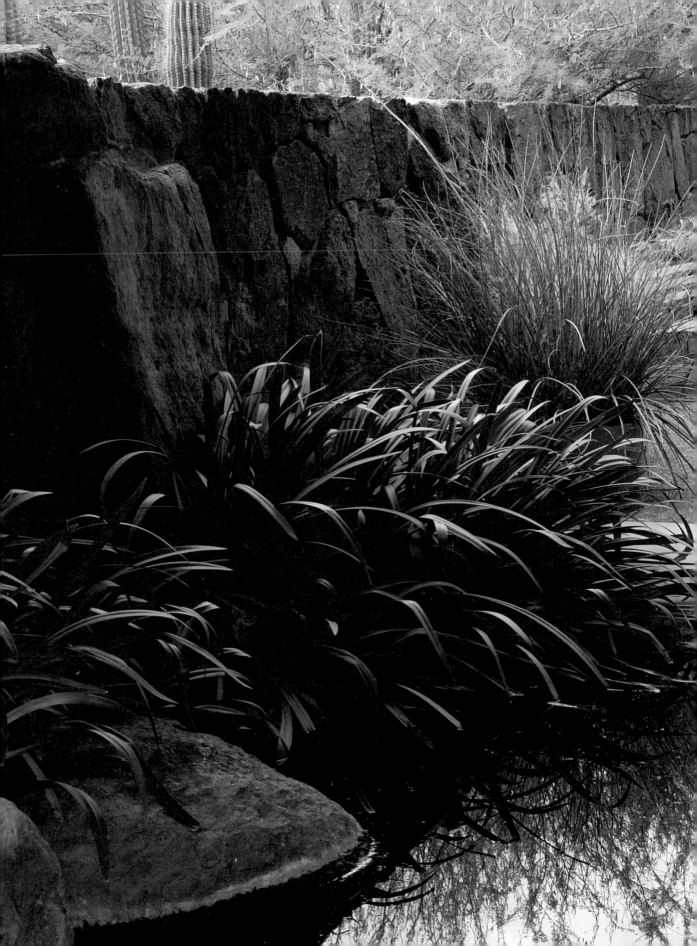

A seep in the rock wall
and the quiet reflection
pool support Sonoran
spider lilies.
PHOTO BY K. DUFFEK

85

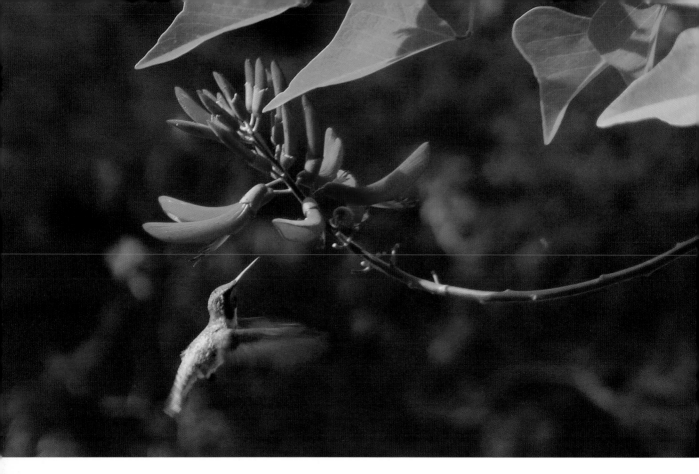

A hummingbird feeds on a coral bean flower in the Desert Garden.

PHOTO BY K. DUFFEK

Bird activity is constant. Lesser goldfinches feed on the seeds of Texas sage, and numerous species of hummingbirds drink from the abundance of red, tubular flowers. Doves, hawks, grosbeaks, thrushes, thrashers, orioles, cardinals, warblers, and more are attracted to the garden's combination of shelter, nesting sites, food, and water.

Beyond the fountain patio is a cul-de-sac sheltered by a large Texas ebony and several blue palms (*Brahea aculeata* and *B. elegans*). The fluted trunks of a Brasil tree are backed by the contrasting texture of an exposed aggregate retaining wall. Snuggled in a corner and sheltered by trees, two benches invite visitors to sit and read. Here, a densely planted berm shelters garden visitors from the hectic traffic on the main path, unseen, just yards away. Large shrubs on the berm create an oasis of green punctuated by masses of agaves, hechtias, and colorful flowers. A native

coral bean amongst the shrubs is one of the largest specimens in the country. (This tropical tree is usually frost-stunted in the United States, but the Desert Museum is fortunate to be nestled into a warm microclimate.) This spot is one of the most exotic, yet least-known corners of the Desert Museum.

Potted plants add interest and color throughout the garden. Some pots contain magnificent specimens of elephant trees (*Bursera* species) or tree ocotillos. One holds a striking *palma de la vírgen* (a cycad) native to the mountains of southern Sonora.

Just beyond the Desert Garden the original Moth Garden overflows with evening primrose and other night-blooming plants—heavy-sweet-scented, pale flowers that attract moths. Because rabbits will eat many of these plants, they are grown in a raised bed behind a wall of native stone. Three species in the dogbane family perfume the air

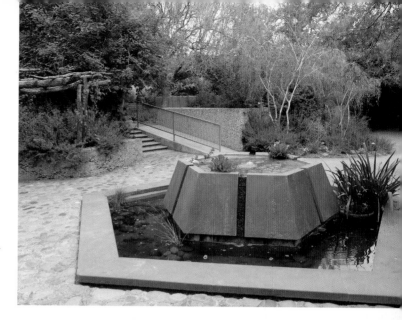

Top — The lower garden, with its hexagonal fountain, evokes the feeling of Mexico City. PHOTO BY K. DUFFEK. *Above* — A white-barked acacia stands out against an exposed aggregate wall. PHOTO BY K. DUFFEK

Opposite — This beautiful pot, installed in the original Desert Garden, is still on display after forty years. PHOTO BY K. DUFFEK

Left — An early photo of the Desert Garden shows its beauty from the beginning. PHOTO BY M. A. DIMMITT

Above — Nacapule rock trumpet fills the evening air with a sweet, delicate scent attractive to sphinx moths. PHOTO BY K. DUFFEK

here. The scent of rock trumpets still lingers in the mornings, but the real perfume powerhouse is a large shrub commonly called Nacapule jasmine. This area is a hotbed of moth activity during the Desert Museum's Summer Saturday Evening programs!

A May 12, 1959, memo from *Sunset Magazine* outlining the proposed "Desert Museum-Sunset Magazine Demonstration Garden" stated: "The purpose of the Desert Demonstration Garden will be to demonstrate to desert residents ways to achieve increased garden or outdoor livability in the desert climate." The Museum's Desert Garden has more than lived up to this purpose. In addition, residents and visitors alike take home lessons about living in greater harmony with the land by "going native." Wherever one lives, people all over the world can help keep this planet's natural systems intact by embracing the beautiful indigenous species adapted to their own area.

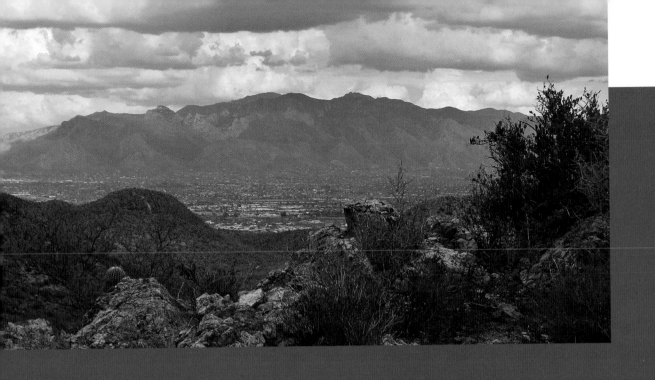

THE LIFE ZONE TRANSECT

BY ERIK RAKESTRAW

Chiricahua, Huachuca, Santa Rita, Rincon, Pinaleño—names as dramatic and romantic as the mountain ranges themselves. Captain John G. Bourke, who chased Geronimo through these very peaks and valleys, wrote in his memoirs, " . . . in no other section can there be found such extreme areas of desert crossed in every direction by the most asperous mountains whose profound cañons are the wonder of the world, whose parched flanks are matted with the thorny and leafless vegetation of the tropics, whose lofty summits are black with the foliage of pines whose graceful branches bend in the welcome breezes of the temperate zone." (J. G. Bourke. 1891. *On the Border With Crook.* Charles Scribner's Sons, New York.) This is the landscape captured in the Museum's Life Zone Transect.

Bourke's description eloquently captures the soul of Arizona's basin and range country, a geological province consisting of broad, flat basins or "desert seas" punctuated by an array of dramatic geologic escarpments, or ranges, known as the "sky islands." More than fifty sky islands (mountain ranges) rise above the desert seas of southern Arizona and northern Sonora (Mexico). Like islands in the ocean, they harbor a mosaic of disjunct and relict life forms separated by vast expanses.

The Santa Catalina Mountains dominate this mountain-island archipelago in the Tucson area. Their pine-clad peaks rise nearly 10,000 feet above the valley's summer swelter, offering refreshing cool breezes to thousands of residents and tourists throughout much of the year. The 30-mile drive from the desert lowland to the top of Mount Lemmon takes less than an hour, offering an environmental experience much like driving from northern Mexico to southern Canada. In fact, for every 1,000-foot gain in elevation there is a 3-degree drop in average annual temperature. It is this temperature drop, combined with increased moisture, that accounts for the diverse habitats one encounters on this road trip. For these

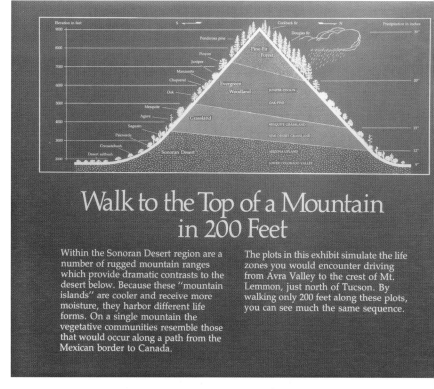

This sign bears a stylized diagram of Mount Lemmon, in the Santa Catalina Mountains. PHOTO BY K. DUFFEK

reasons the Arizona-Sonora Desert Museum chose the Santa Catalina range as its model for a Life Zone Transect—a specialty garden showcasing biotic communities.

Established in the early 1960s, the Life Zone Transect interprets the changes in vegetation along the desert-to-mountaintop drive. From low valley creosote flats to the mixed conifer forest, the exhibit transects the region's eight major biotic communities.

The life zone concept was the brainchild of Clinton Hart Merriam who, in 1898, published a study of the life zones of the San Francisco Peaks, near Flagstaff, Arizona. For a variety of reasons, Mother Nature doesn't always observe the clean tight borders

Top — Visitors can "climb" from chaparral habitat to pine forest by walking about 30 feet along the trail! PHOTO BY E. RAKESTRAW

Bottom — Great beauty is found in the mixed conifer forest in the Life Zone Transect. PHOTO BY E. RAKESTRAW

The oak woodland in the Life Zone Transect is shady and inviting. PHOTO BY E. RAKESTRAW

that Merriam described, so the Desert Museum simplified, using the basic concept to display the Santa Catalina's eight most obvious biomes or subdivisions. The condensed proximity of these model biomes aptly demonstrates their differences and similarities. The Museum's Life Zone Transect exhibit is arranged in a linear fashion, so that visitors walk a flat path as they "climb" through biomes starting on the desert floor to the mixed conifer forest found at the top of the Santa Catalina Mountains.

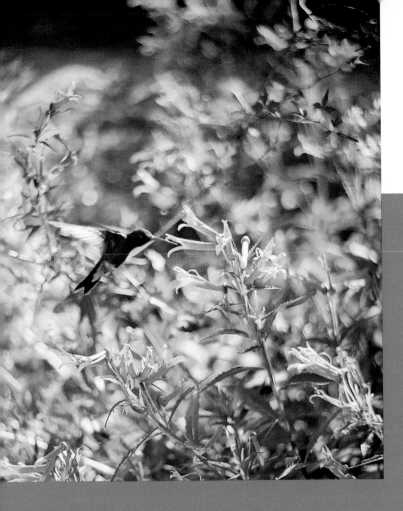

The Hummingbird Exhibit

BY KIM DUFFEK

H ummingbirds are little jewels that never cease to fascinate with their aerial antics. With long narrow beaks and the ability to hover, they are highly specialized for feeding on flower nectar and small soft-bodied arthropods. Many of the flowers they feed on are also specialized for these tiny aviators, and that has guided the choices for our plant palette in the Desert Museum's award-winning Hummingbird Aviary.

Flowers of different plant species may be pollinated by a variety of agents, including wind. However, efficient, precise transfer of pollen between individual plants of the same species reduces the need to produce copious quantities of pollen and helps ensure successful reproduction, so there are advantages to specific relationships between a plant species and a particular species of pollinators. A hummingbird-pollinated flower is tubular in shape, and usually red or orange. A hummingbird has a long narrow bill and eyesight that is keen on red colors. Because of their respective shapes, pollen brushes off the flower onto the bird's head as it feeds and is transferred to the stigma of the next flower it visits in its search for nectar.

A sign at the entrance of the Hummingbird Aviary shows the kinds of hummingbirds a visitor is likely to see. PHOTO BY K. DUFFEK

Opposite — Orange cardinal flowers, with their long tubular shape, are hummingbird magnets. PHOTO BY K. DUFFEK

Originally opened in 1988, the walk-in Hummingbird Aviary was expanded to its present dimensions in 1992. Nectar plants in the Aviary provide for natural foraging for up to seven species of hummingbirds, while unique feeders allow for nectar supplements when needed. Hopbush, Arizona rosewood, and other dense native shrubs create cover and nesting spots.

For any hummingbird garden, nectar plants are a key component. Selections should maximize the availability of flowers throughout the year. The Museum's Hummingbird Aviary usually abounds with red, orange, and yellow flowers. Penstemons (*Penstemon parryi* and others) and fairy dusters bloom in early spring. Yellow and orange Mexican cardinal flowers also appear, along with deep coral-red betony. Coral bells, golden columbine, slipper flower, and several sages add to the show. Then ocotillo and coral beans bloom, with Baja fairy duster, yellow trumpet bush, and red Mexican bird of paradise blooming through most of the summer and fall. Red hesperaloes, desert honeysuckle, and various hummingbird-attracting cacti round out the floral menu.

Opposite, top — Mass plantings in the Hummingbird Aviary attract hummingbirds. PHOTO BY K. DUFFEK

Opposite, bottom — These unique copper feeders allow for supplementary nectar. PHOTO BY K. DUFFEK

Above — Outside the aviary, mass plantings of hummingbird plants attract birds to the area. PHOTO BY K. DUFFEK

Right — Fairy duster is loved by hummingbirds. PHOTO BY M. A. DIMMITT

Outside the Hummingbird Aviary, African and other exotic aloes, (which feed nectar-feeding sunbirds in their native lands), provide winter and spring nectar for wild "hummers" at the Museum. Native chuparosa, Sonoran justicia, and betony flourish on the margins of that plaza.

Throughout the late winter and early spring, several females sit on bean-sized eggs and raise young in thimble-shaped nests spun with spider webs and decorated with bits of bark and leaves. The males play no role in rearing the young, but continue to show off their colors by day and roost in dense shrubs at night. Visitors can glean much about the habits of these fascinating birds by sitting quietly on one of the aviary benches.

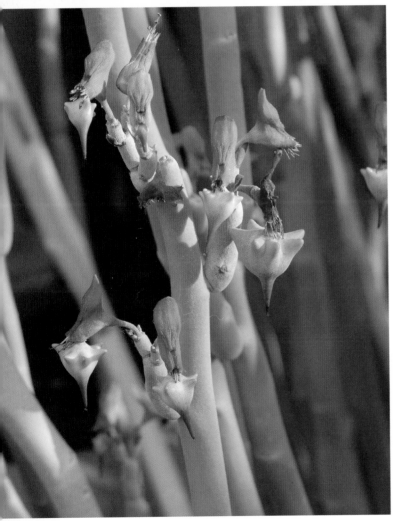

Top — This male hummingbird is defending his territory, a yellow trumpet bush. PHOTO BY K. DUFFEK

Left — Slipper flower has the shape that encourages pollination by hummingbirds. PHOTO BY K. DUFFEK

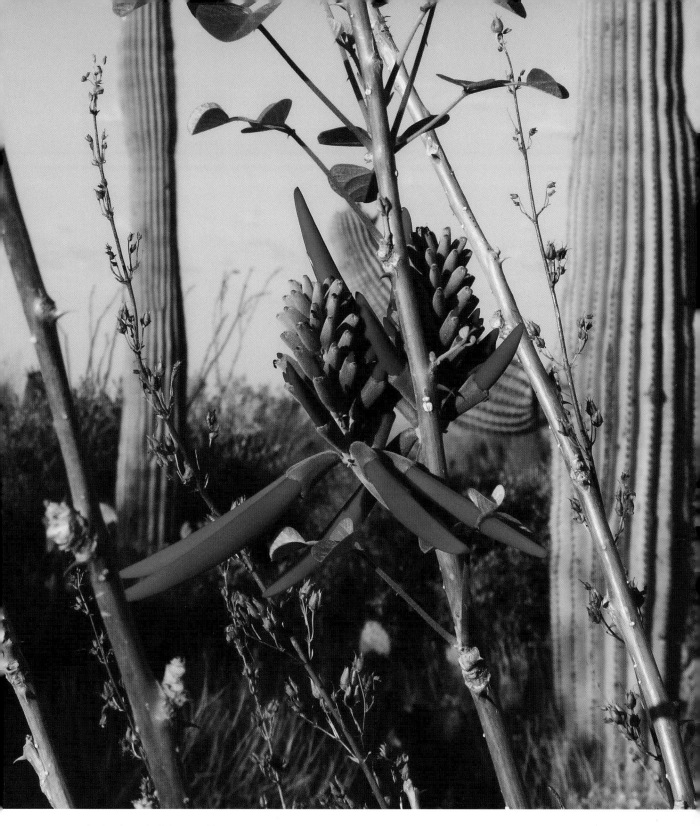

The bright red of this coral bean is a beacon to hummingbirds. PHOTO BY K. DUFFEK

Left — Red hesperaloes are another hummingbird favorite. PHOTO BY K. DUFFEK

Above — Ocotillos bloom in the spring, as hummingbirds migrate north through the Desert Southwest. PHOTO BY K. DUFFEK

Above — Plants attractive to hummingbirds border the path to the Hummingbird Aviary. PHOTO BY KIM DUFFEK

Left — A quiet bench in the Hummingbird Exhibit offers an excellent view of these fascinating birds. PHOTO BY KIM DUFFEK

Opposite — Aloes and Sonoran justicia provide nectar in late winter; this dense planting outside the Hummingbird Exhibit attracts hummingbirds year-round. PHOTO BY J. H. WIENS

The Desert Museum has been the most successful institution in the world at producing and keeping hummingbirds. That the birds thrive in a walk-in aviary with people constantly passing by is a tribute to the diverse and talented team that designed the exhibit!

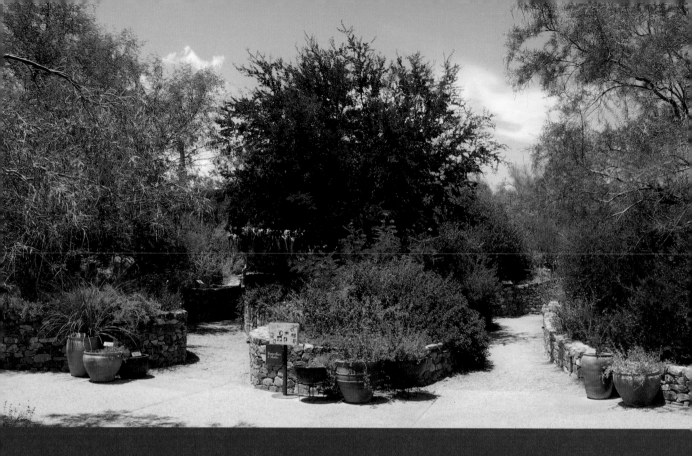

The Pollinator Gardens

BY JULIE HANNAN WIENS

lmost all plants reproduce sexually, and the outcome of sex in flowering plants is seeds. But unlike animals, plants cannot move around looking for mates. They must employ an outside agent to move the male part (pollen) to the female part (stigma). Many plants are wind-pollinated or are self-pollinating, but the majority of flowering plants rely on animals to perform this service for them. The Pollinator Gardens at the Museum (of which the Hummingbird Exhibit is a part, see Chapter 9) interpret pollination ecology using plants pollinated by hummingbirds, butterflies, moths, bees, and bats. It is a series of gardens vibrant with life and color, and packed with fascinating facts.

Butterflies and Moths (Lepidoptera)

Butterflies and moths are closely related, but the flowers they pollinate are quite different. Butterflies are active by day, so the flowers they pollinate bloom during the day, sporting bright colors and often a sweet scent. Moths are nocturnal, and moth-pollinated flowers open at dusk or after dark; they are white or pale in color, which makes them highly visible in dim light. Moth-attracting flowers tend to have a heavy-sweet fragrance that carries long distances.

A successful butterfly or moth garden includes not only the proper species of nectar plants, but also larval food plants and a source of water or mud. In the Museum's butterfly garden, larval food plants can look a bit ragged after supporting a good crop of caterpillars, so for a home garden you might want to locate them in a less conspicuous location.

Some food plants for our more common and attractive lepidopteran caterpillars include pipevines (*Aristolochia* species), milkweeds (*Asclepias* species), legumes (*Senna* species) and passionflowers (*Passiflora* species). Milkweeds are especially attractive to queen and pipevine swallowtail butterflies. Both the larvae and the adults of these butterflies consume milkweed plants, and both have distinctive bright warning colors advertising that their bodies contain poisons acquired from the plants upon which they feed. Predators leave them alone, or quickly learn to do so. Nectar of the flowers of the fine-leaved Arizona milkweed is a favorite of many species of

Opposite — The raised beds in the Pollinator Gardens keep rabbits out. PHOTO BY J. H. WEINS

Below — The larvae (caterpillars) of this monarch butterfly feed exclusively on milkweeds (Asclepiadaceae, especially *Asclepias* species), many species of which are becoming rare in the Southwest due to habitat loss. From the milkweeds, the caterpillars extract cardiac glycoside poisons that pass into the adult butterflies to protect them from predation. PHOTO BY W. HORNBAKER

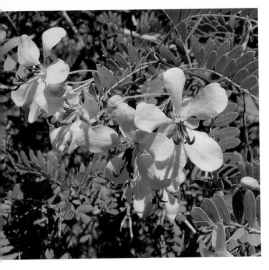

butterflies and other pollinators. Pipevine swallowtail butterflies are often seen at pipevine plants. Yellow-flowering senna plants are highly desired by the many species of white and sulfur butterflies. Southern dogface and sleepy orange butterflies search out these plants. Bright orange and silver gulf fritillaries lay eggs on passionflower plants.

The fragrance of lantana and chocolate flower draws both butterflies and human visitors. In our Pollinator Gardens, visitors may witness queen butterflies daintily sipping nectar from blue butterfly mist flowers, gray hairstreaks flitting around small, yellow-flowered golden fleece, or pipevine swallowtails gliding toward the vermillion petals of Mexican bird of paradise.

Butterflies need sunny spots to warm up. Look to rocks and open places to see them sunning in the morning and on cooler days. Shelter is also necessary for protection from wind and predators. Texas ebony, mesquite trees, and wolfberry all offer good protection.

In spring, desert four o'clock drapes over walls in the Museum's moth garden, displaying masses of bright

Top — Arizona milkweed is especially attractive to queen and monarch butterflies; caterpillars eat the leaves, and adults consume the nectar. PHOTO BY J. BROOME

Middle — This pipevine (*Aristolochia quercetorum*) is pollinated by flies, but its leaves are the preferred food of pipevine swallowtail caterpillars. PHOTO BY M. A. DIMMITT

Bottom — Palo prieta (*Senna polyantha*) is a large, drought-hardy shrub with translucent seedpods; the leaves are a favored food of butterfly caterpillars. PHOTO BY M. A. DIMMITT

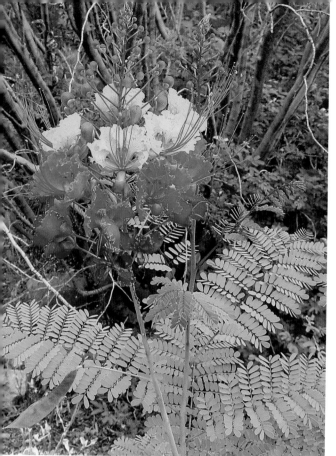

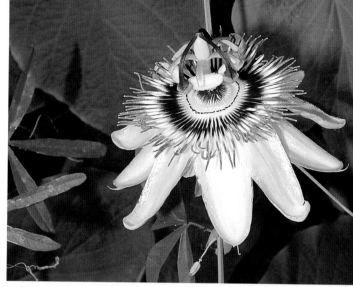

Top, left — Red bird of paradise attracts
hummingbirds and several kinds of butterflies.
PHOTO BY M. A. DIMMITT

Top, right — Flowers of the passion vine are
particularly stunning and complex and very attrac-
tive to butterflies. PHOTO BY M. A. DIMMITT

Right — Trailing lantana (*Lantana montevidensis*)
can bloom for several months in the late winter
and spring. PHOTO BY M. A. DIMMITT

purple flowers every evening. Night-blooming hesperaloes also draw
moths to their ivory blooms. Through the dog days of summer, the large,
fragrant flowers of the tufted and Hooker's evening primroses pop open
with a visible jerk before sunset. Hawkmoths power-sprint from flower to
flower in this bed, sipping nectar and inadvertently transferring pollen to

Top left —The bright green foliage of Texas ebony tree offers year-round protection for butterflies from wind and inclement weather. PHOTO BY K. DUFFEK

Above — Desert four o'clock is a showy, fragrant addition to any night-blooming garden. PHOTO BY M. A. DIMMITT

Left — Yellow evening primrose and large white jimson weed flowers draw the attention of a variety of moths on warm summer evenings. PHOTO BY K. DUFFEK

successive plants. Like humming-birds, they can hover. They will also dive deep into large flowers such as sacred datura.

Bees as Pollinators

Bees are one of the most important pollinators; they are responsible for the majority of the world's pollination services, including one-third of our food crops. To most

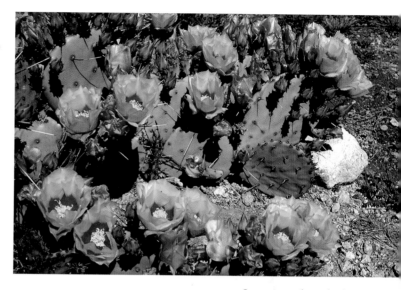

Sometimes, bees don't have to go very far to cross-pollinate flowers, as with this longspined prickly pear cactus.
PHOTO BY M. A. DIMMITT

people, "bee" means honeybee, but this is just the introduced Old World species. The Sonoran Desert has an estimated one thousand species of native bees—mostly docile, solitary species. Bees are attracted to brightly colored, sweet-scented flowers, especially those with horizontal petals and easily accessible nectar.

Most cacti are bee-pollinated, and numerous native bee species specialize in visiting these spiny wonders. When a bee visits a prickly pear or cholla flower, the stamens curl inwards and tightly surround the bee. The bee rolls around in the wall of pollen and gathers up as much as possible. Most of the pollen will feed its larvae, but some will be deposited on the stigmas of other flowers visited.

Most members of the sunflower family (composites) specialize in attracting bees. Desert zinnia, paper flowers, and desert marigold are good arid land examples.

Carpenter bees and some others put on quite a show when buzz-pollinating flowers. Plants in the nightshade family have anthers that open only by a small terminal pore. While clinging upside down to the flower, the bee vibrates the flower using its flight muscles, which shakes the pollen out onto the bee.

At the Desert Museum, we encourage the nesting of female carpenter bees, which lay their eggs in dead wood, by using a fence of dead sotol stalks. The bees bore holes in the stalks, and then fill them with pollen for their larvae.

Nectar Bats

Nectar bats are important pollinators in the tropics, and the Sonoran Desert is on the edge of the tropics. While most bats are insectivores, three species of nectar-feeding bats migrate from central Mexico to the Desert Southwest each summer: the greater and lesser long-nosed bats (*Leptonycteris nivalis; Leptonycteris yerbabuenae*) and the Mexican long-tongued bat (*Choeronycteris mexicana*). Only pregnant females migrate as far north as Arizona. They come here to raise their young on the abundant supply of flowers and fruit of columnar cacti, then return south

Top — This desert marigold provides plentiful takeout food for active bees. PHOTO BY M. A. DIMMITT

Bottom — Sonoran nightshade, which belongs to the same family and genus as tomatoes and potatoes, is buzz-pollinated by bees. PHOTO BY M. A. DIMMITT

DESERT GARDENS

using agave nectar as their main fuel. Bats don't fly close to the ground. Bat-pollinated plants such as agaves, yuccas, saguaros, and organ pipe cactus bear their flowers up high in the bats' flight paths. Bat flowers usually smell like ammonia or overripe fruit.

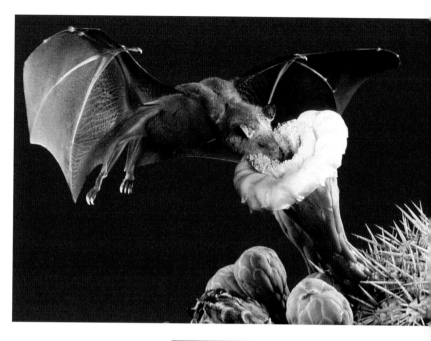

Gardening for pollinators is rewarding on two levels. The flowers provide colors and fragrances that are (usually) pleasing to humans, and at the same time they create habitat for native wildlife. We can have a positive impact on pollinator populations by the informed choices we make in our own gardens.

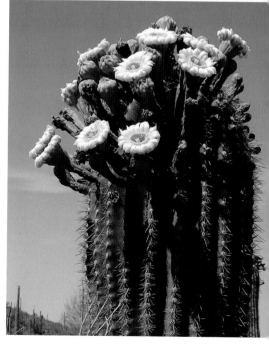

Top — Nectar bats, like this lesser long-nosed bat, are nighttime pollinators of columnar cactus and yucca flowers. PHOTO BY M. TUTTLE

Bottom — Sturdy, musk-scented flowers that are located high above ground level, as on this saguaro, are most attractive to bats. PHOTO BY M. A. DIMMITT

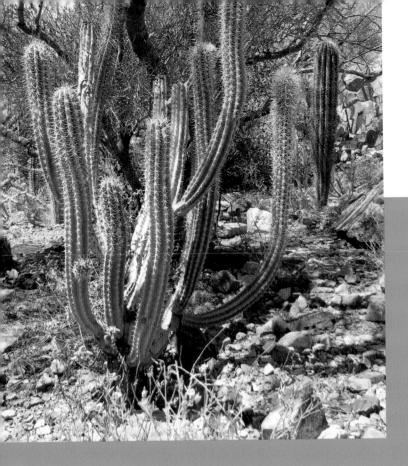

Convergent Evolution Exhibit

BY ERIK RAKESTRAW

"These plants are not peyote" read the sign, in reference to the inconspicuous, fleshy buttons nestled among the rocks. Coveted by thrill-seekers of the counterculture for what they are not, these succulent little plants are pretty cool for what they are: representatives of convergent evolution. This Desert Museum exhibit is not a psychedelic buffet but a demonstration garden showing the similar ways plants evolve and adapt in response to parallel environmental conditions and constraints.

Times have changed and the peyote sign has long since been removed, but the plants remain. Planted together in this garden for easy comparison, New World cacti seem to emulate Old World euphorbias, showing how these plants, although not at all closely related and separated by thousands of miles, have evolved to look remarkably alike and fill similar ecological niches. This is the meaning of "convergent evolution."

Denizens of the deserts—cacti, euphorbs, agaves, and aloes—have all evolved very similar survival strategies. In fact, plants in all of the world's drylands have three main options of adaptation: succulence (water storage), drought dormancy (shutting down), and drought avoidance (abbreviated life cycle). Succulents must adopt certain additional characteristics to absorb and safeguard their precious hoard of water. Adaptive options are limited, such as pleats

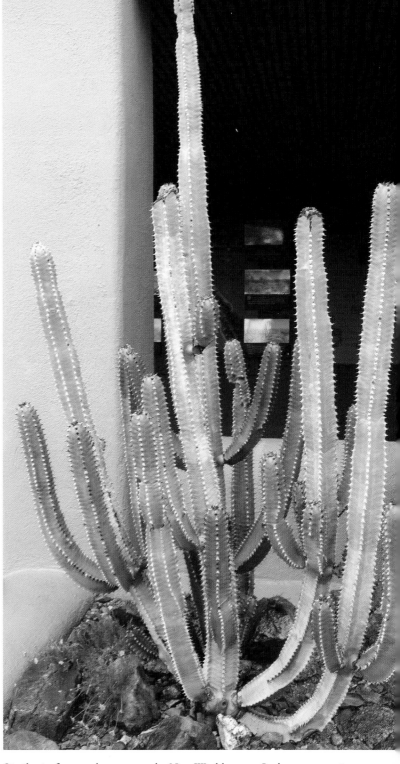

Similar in form and structure, the New World cactus *Pachycereus gatesii* (*opposite*) and the Old World euphorb *Euphorbia canariensis* (*above*) are not at all closely related. PHOTOS BY E. RAKESTRAW

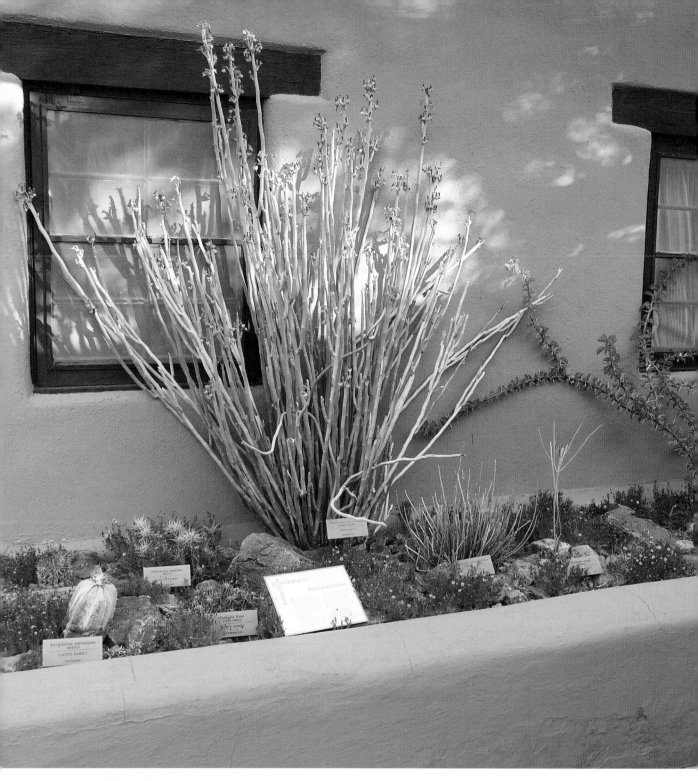

This is one of three planters at the Museum showing many examples of convergent evolution among dryland plants.
PHOTO BY K. DUFFEK

to expand with water without splitting, and spination or toxins to ward off predators.

Here is a classic example of convergent evolution in the exhibit— *Pachycereus (Lophocereus) gatesii* of Baja California Sur (Mexico), and the Canary Island spurge (*Euphorbia canariensis*) of their namesake islands off the coast of West Africa. Although separated by thousands of miles, because these two plants inhabit similar physical environments that drive their morphological evolution, they are extraordinarily similar in appearance. Both are multi-stemmed, succulent, candelabra-like, spiny plants. But the similarities are superficial. Cacti and euphorbias are much more different than they are similar. The best indication of their unrelatedness is in their very different flowers, which quickly reveal that they belong to entirely different families.

The Convergent Evolution Exhibit at the Desert Museum has itself evolved through several incarnations and locations. The current location near the Museum's main entrance makes it an ideal jumping-off point for visitors. With easy to understand signage, and unique forms and structures of species from near and far, this exhibit enhances visitor knowledge and hopefully corrects erroneous notions about adaptation and plant life of aridland communities.

Rooftop Gardens

BY GEORGE M. MONTGOMERY

I nterest in living, or "green," roofs has blossomed in the last decade, as evidenced by the growth of related organizations, certification programs, and new municipal codes. Reduced heating and cooling costs, diminished storm water runoff, lowered urban heat-island effect, and enhanced visual appeal are all benefits of buildings that accommodate living vegetation on their roofs. The scope of rooftop garden design is broad and ranges from complete coverage with elevational contours and

mixed planting schemes, to shallow turf areas, to a few potted specimens. The Arizona-Sonora Desert Museum was a pioneer in the use of living roofs.

Several buildings in the Museum have green roofs. For example, the Warden Oasis Theater at the Desert Museum was designed with a rooftop planter to create a line of vegetation that softens the building's visual impact from several viewpoints. The L-shaped planter is 45 feet long and 4 feet wide.

Roof construction below the planter was engineered to support soil, irrigation water, heavy rain events, and the ultimate weight of mature vegetation. Drainpipes allow excess water to seep out. The plants were installed in 2007 and within a year began to grow above the high, second roofline. In keeping with a low-water-use and minimal-care guideline, the selection of species for the Theater's roof garden was straightforward. A feather tree hides a rooftop ladder. Foothills palo verde, ocotillo, jojoba, and creosotebush also grow there. This planter rarely requires irrigation.

Largely unnoticed, ten other living roofs flourish at the Desert Museum. The roof of the concrete

Grasses and yuccas grow on the living roof at the Museum's Grasslands Exhibit. PHOTO BY G. M. MONTGOMERY

ramada at the Grasslands Exhibit has 1 to 2 feet of soil planted with a variety of grasses. Without this green covering, the stark roof would be an eyesore from the Museum's entrance overlook.

For the same reason, and to better immerse visitors in the habitat, the roofs of service areas at the Mountain Woodlands Exhibit are vegetated with yuccas, wolfberry, rosewood, and pines. Most caves are in limestone hillsides, and these hills usually have characteristic vegetation, ocotillo

The rooftop of the Earth Sciences Exhibit is landscaped with typical limestone hill flora.
PHOTO BY G. M. MONTGOMERY

DESERT GARDENS

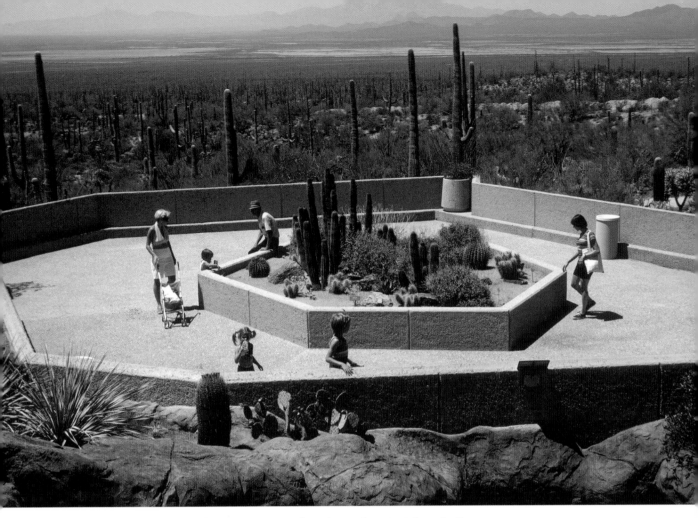

These organ pipe cacti in the Cat Canyon rooftop planter thrive in 2 feet of soil.
PHOTO BY A. MORGAN

often being a dominant feature. With ocotillo and sandpaper bush, the hill covering the Earth Sciences Cave and Mineral Hall replicates these limestone soil habitats; it has been in place since 1980.

Other exhibits at the Desert Museum with living roofs include: Life Underground, Underwater Riparian Viewing Exhibit, and the visitor platform above Cat Canyon.

GUEST ESSAY

MARY IRISH

will never remember the year, but I certainly remember the plants. I had been working for some time to rev up a plant introduction program at the Desert Botanical Garden (DBG) in Phoenix. I was growing and selling not only species from the collection, but some whose seed I had secured in the wild, as well as promising species from other gardens and colleagues throughout the region.

I found out that the Desert Museum staff had been working on much the same effort but with a completely different group of plants than the ones I had. Calls were made and I came down for a visit and met horticulturist John Wiens. He was enthusiastic, he was generous, and we nearly talked ourselves to death in our mutual enthusiasm. He gave me a number of stock plants that day, but the two that remained forever in my

heart were Sonoran nightshade (*Solanum*) and Nacapule jasmine (*Vallesia*). I brought them back to Phoenix and propagated them. I had a small cadre of willing volunteers and members at DBG who enthusiastically put my offerings in their gardens and kept track of them for me to see how they performed. These two species

Nacapule jasmine.
Photo by M.A. DIMMITT

were a part of the last distribution I made out of that program before I left the garden.

All of the plants from that program were lost when I left DBG, and my own *Solanum* died a premature death, which I still greatly mourn. My *Vallesia*, however, is still one of the stars of my garden, arresting all visitors with its delicious, sweet aroma during its long flowering season. Like so many of the plants in my yard, they speak to me of long-ago friends, associates from all over the country who are generous with their plants, but few plants have such a fond place in our garden as that *Vallesia*.

Not long ago, I was working in the garden of one of those faithful trial gardeners and I was astonished to find, along the fence line, a *Vallesia* equal in stature to mine. And to my delight, a sturdy *Solanum* in full bloom accompanied it. I felt like I was meeting an old friend! I was reminded again of how the generous gesture of giving pieces and parts of your plants ensures that, no matter the vagaries of life, they never get entirely lost. Both of these well-loved plants are a tribute to the work and the considerable know-how of the Arizona-Sonora Desert Museum.

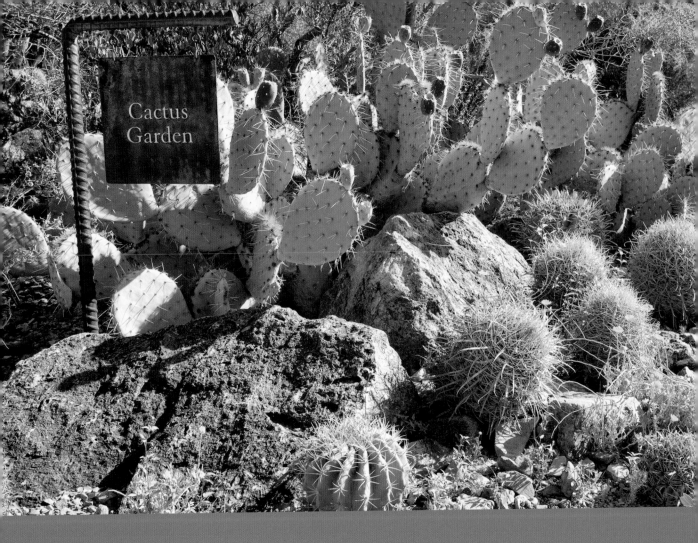

Cactus Garden

The Cactus Garden

BY JEFFERY MOORE

Some people consider cacti necessary to daily life as food or building materials. Others consider them to have religious significance and consume plants containing psychotropic chemicals, such as peyote, to induce an altered state of consciousness during spiritual ceremonies. Many people consider cacti to be a nuisance, perhaps remembering a close encounter of the spiny kind. And, a tiny fraction of Earth's

population is simply enthralled by these extraordinary members of the plant kingdom.

However they are perceived, cacti deserve respect for their ability to survive some of the harshest environments in the world. Some cacti have evolved to survive in areas that frequently go a year or more without rain. Some tropical cacti in extremely wet habitats have evolved to live in rocks that dry quickly, whereas others in that situation have adapted to living high in the trees, above the waterlogged soil. Most cactus habitats, however, are hot and dry, which is why so many cactus lovers spend so much time in the sun.

The Cactus Garden

The Museum's Cactus Garden is a spiny, succulent, botanical journey. Imagine walking through all the different cactus habitats of the Sonoran Desert. One step takes you to the Baja California peninsula, amid huge organ pipe cactus and yellow-spined barrel cactus. The next step sweeps you to the tropics of southern Sonora, mingling with Sonoran old man cactus, *etcho*, and *sahuira*. The final steps bring you into Arizona and northwestern Sonora, among awe-inspiring giant saguaro, fish-hook barrel cactus, and chain-fruit cholla.

Opposite — The cactus garden entrance features several varieties. PHOTO BY R. SPENCER

Top — Saguaro wood, the intriguing "skeleton" of the saguaro cactus, has been used for centuries as support for walls and ramada roofs. PHOTO BY J. BROOME

Bottom — Prickly pear fruit is delicious and often made into syrups and jams. PHOTO BY J. BROOME

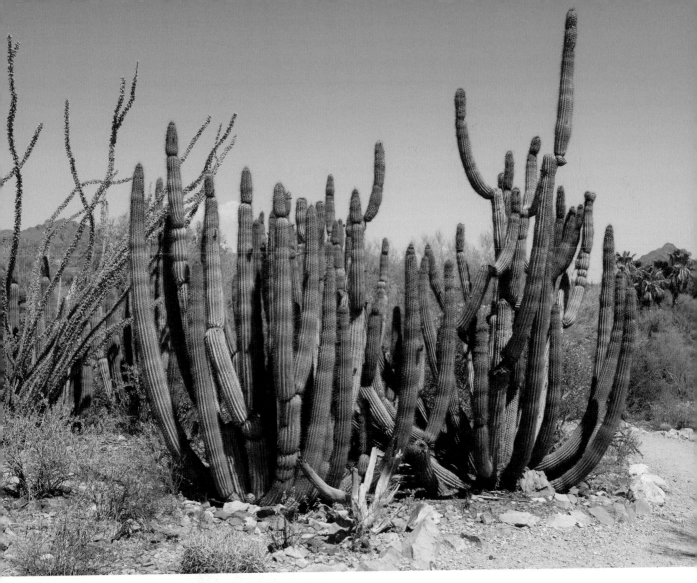

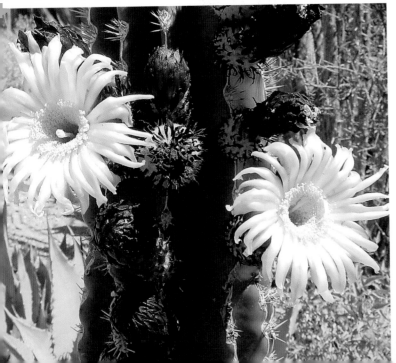

Above — The organ pipe cactus can reach 40 feet in height at the southern extent of its range in Mexico. The fruit of this cactus is one of the sweetest in the desert, lending the common names *pitahaya dulce* or sweet pitahaya to this species. PHOTO BY J. BROOME

Left — *Etcho*, or *cardón barbón*, plants reach 7 feet in height and produce spectacular white flowers that are pollinated by nectar-feeding bats. PHOTO BY M. A. DIMMITT

Right — For many, the saguaro is the signature plant of the Sonoran Desert. PHOTO BY J. BROOME

DESERT GARDENS

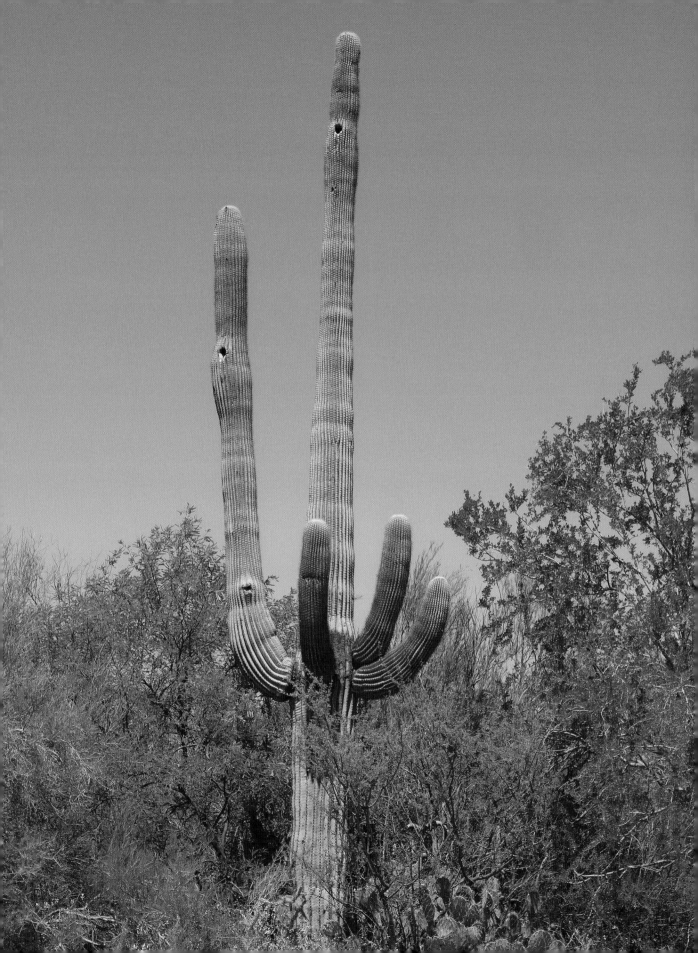

Above — Many species of pincushion cactus (*Mammillaria*) occur in the Sonoran Desert Region; this one is *M. standleyi*. PHOTO BY J. BROOME

Left — The garden honors John Haag, the first president of the Tucson Cactus and Botanical Society, as seen on the original Cactus Garden plaque, on "Haag Rock." PHOTO BY J. BROOME

Prickly pear cacti (*Opuntia bravoana*), sometimes called *nopales*, are nearly ubiquitous in New World desert landscapes. PHOTO BY J. MOORE

To the casual observer it may simply be an attractive arrangement of barrel cactus nestled among foothills palo verde trees, or smaller pincushion and hedgehog cacti in raised planters that bring them closer to curious observers. Careful observers, however, will note that the plants are arranged taxonomically, based on their evolutionary relationships. Cactus lovers will take the opportunity to compare similar species and discover just how they differ. And what better way to learn about that most fascinating of plant families, the *Cactaceae*.

Historically the Cactus Garden was larger than it is now and laid out in a loop. Over time other exhibits were built at the Museum, and the garden went through some alterations. Although the available space was reduced, it gave us the opportunity to reconsider design concepts.

The long-spined golden hedgehog, *Echinocereus nicholii*, is beautiful. PHOTO BY J. MOORE

We gained a new entrance on the south side, a very important improvement because most cacti have a natural southward lean, and this slight lean, combined with backlighting most of the year, creates a better view from the south. Fortunately their shallow roots are very strong and thick at the base, keeping them upright like perilous protectors of the desert.

The Desert Garden highlights the three most numerous types of cacti in the Sonoran Desert region: barrels, hedgehogs, and opuntioides (cholla and prickly-pear). There are many other cacti that grow in our desert, but they are not as abundant. Columnar cacti are highly visible, but only a handful of species are found in our region. Pincushions and other small species are also present.

The garden also showcases boojums, or cirios, which stand like spiny white candles among cacti, creosote, and agaves—reminiscent of Baja California deserts. The brilliant red flowers of ocotillo often punctuate this garden and they are here in abundance, including some rare yellow-flowered specimens.

Cirio, or boojum, is a close relative of ocotillo. PHOTO BY R. SPENCER

Design

An appealing cactus garden requires an attractive placement of cacti and other succulents enhanced with non-succulent plants. There is no strict design format for any type of succulent garden, but gardeners would do well to avoid an artificial or overly tight arrangement. A potential

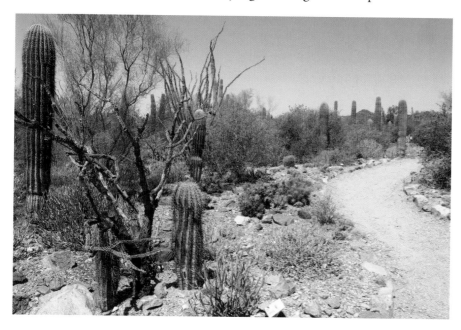

In a cactus garden, non-succulent plants provide a natural setting, as well as shade.

PHOTO BY J. MOORE

advantage to planting species from the same geographic region together would be their similar watering requirements.

Irrigation

Rate of evaporation is important to consider when installing an irrigation system in the desert. The daytime manual sprinklers we originally used in the Cactus Garden were unsuitable for this reason. Various forms of drip irrigation were also discarded, since much water flowed past the shallow root zone. Currently, we have returned to sprinklers, but with a twist: pop-up lawn sprayers are proving effective because they cover a wide area, can run during the night to reduce evaporation, and are retractable to stay out of sight during the daytime when visitors are in the garden.

Sprinklers are also effective for cactus because of their spines. In addition to protection of the plant body and flowers, spines collect moisture! Water from a light rain or fog collects on the spines and plant surface and moves down the stem to the root zone. We cannot predict where the roots are, but we can reproduce the natural processes to improve irrigation.

The Museum's Cactus Garden is a great place to learn about cactus and other succulents. The plants are magnificent, and our highly informative labels are unique in the public garden world. In addition to the basic scientific and common names and origin information, they include a map of the region, with gray denoting the Sonoran Desert and a black area or a small dot indicating the natural location for the species. In some cases, flower images are added for the benefit of visitors who arrive when the plants are not blooming.

Above — Use caution when gardening around *Cylindopuntia molesta*! PHOTO BY J. BROOME

Right — The unique Desert Museum plant species labels provide information on geographic range and flower appearance. PHOTO BY J. BROOME

STRAWBERRY HEDGEHOG
SINITA BARBONA

Echinocereus engelmannii
CACTACEAE (CACTUS FAMILY)

The Agave Garden

BY JEFFERY MOORE

T here are approximately three hundred species of agaves in the
world, all belonging to the genus *Agave*. About fifty species are
known from the Sonoran Desert Region. Agaves occur from
northern South America and throughout the Caribbean, to the southern
United States as far north as West Virginia. More than one hundred
twenty-five species grow in Mexico, which is the center of diversity for
the group.

Recently, botanists have organized the genus *Agave* into three groups (subgenera): *Agave, Littaea, Manfreda*. The *Agave*-group usually has heavily armed leaves and a branched inflorescence. Species in the *Littaea*–group are typically unarmed and have a spikelike inflorescence (cluster of flowers on a single stem). *Manfreda*, which does not occur in the Sonoran Desert region, has annual leaves with a spikelike inflorescence.

Agave Structure

Most agaves have short, essentially hidden stems. The stem is fibrous and stores some moisture, but more importantly it stores energy. As with other plants, the leaves arise from this stem. In agaves, the leaves are arranged by what is called the Fibonacci angle (a 137.5 degree angle), giving the plants their attractive spiral appearance and maximizing the amount of light available to the leaves. The leaves also direct water to the roots, an important adaptation in areas with little precipitation.

Opposite — The naturally peeling fibers of *chahuiqui* (*Agave multifilifera*) give it a distinct appearance. PHOTO BY J. MOORE

The leaves of some species have smooth margins, while others have razorlike teeth and are tipped with a terminal spine as sharp as the finest sword. These teeth give rise to a striking feature that adds to the beauty of agaves. As leaves grow from the stem, they press out against the previous set and inward to the next set, imbedding impressions of their shape on the adjacent leaves. The striking pattern created by this process is termed leaf imprinting or bud printing.

Below — The flowering stalk of *Agave chrysantha* is a striking sight. PHOTO BY M. A. DIMMITT

The roots are annual, lasting one year or one season. Each year, new roots form to anchor the plant to the earth. When the plants prepare to flower, they send a

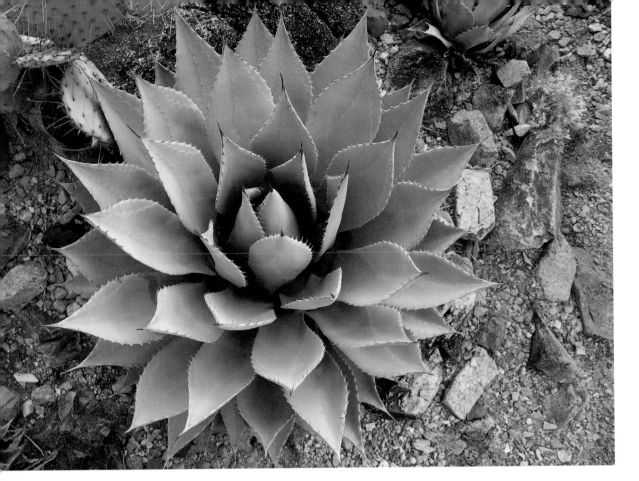

Above — An overhead view of the Huachuca agave (*Agave parryi huachucensis*) highlights the spiral leaf arrangement off the hidden stem. PHOTO BY J. MOORE

Left — The flower stalks of Shaw's agave (*Agave shawii*) will reach up to 12 feet before flowers begin to open. PHOTO BY M. A. DIMMITT

massive inflorescence skyward, as high as 40 feet in some species. The rise of these large flowering stalks is driven by stored energy in the stem, and once the plant has flowered, the stalk and stem usually die.

The inflorescence can be with or without branches (paniculate or spicate). Paniculate species are pollinated primarily by bats, while spicate species are pollinated primarily by insects. Many bird species feed on agave flowers and aid in pollination. The flowers are upright, not pendulous like yucca flowers.

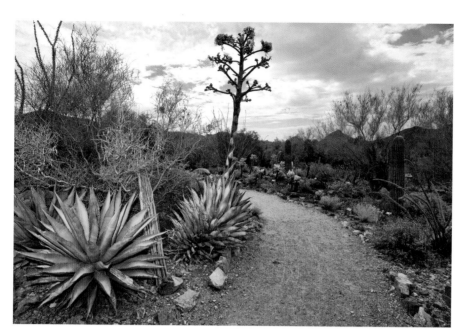

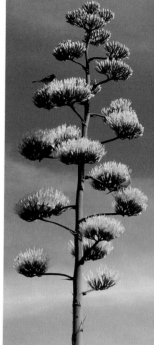

Above — At the end of an agave's life, the leaves are dead and brittle, and the seeds have scattered. PHOTO BY R. SPENCER

Above, right — Spreading flower clusters are typical of the panicles in the subgenus *Agave*. This species, *Agave parryi*, includes orioles and woodpeckers in its suite of pollinators. PHOTO BY M. A. DIMMITT

Right — In members of the subgenus *Littaea*, the inflorescence is a spike, and the flowers arise directly off the stalk (*Agave polianthiflora*). PHOTO BY M. A. DIMMITT

Since most agaves are monocarpic (flower once and die), the plant is essentially dead when it is flowering. What keeps the stalk from falling over? All those years of new annual root growth! Agaves almost always win the battle with gravity until the flower stalk or the plant decomposes enough to collapse.

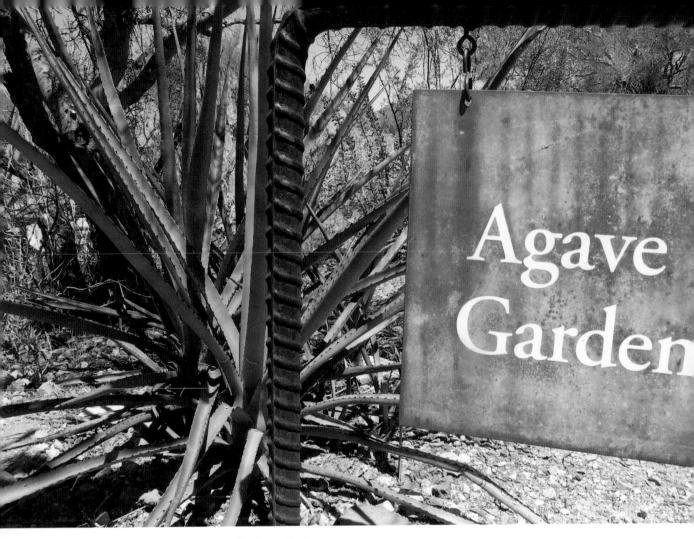

This rustic entry sign directs visitors into the Agave Garden. PHOTO BY J. MOORE

The Desert Museum's Agave Garden

The Museum's Agave Garden was established in 2005 as a loop trail. With about one hundred fifty plantings, it now displays most of the agave species found in the Sonoran Desert, including the spicate agaves, the group *Littaea* (mostly plants from higher elevations and possessing less armature), and paniculate agaves, species of the subgenus *Agave* itself, with their well-developed and beautiful marginal teeth. Members of the latter group tend to occur in much drier areas and have a need to discourage herbivory by thirsty animals, hence their strong, defensive spines.

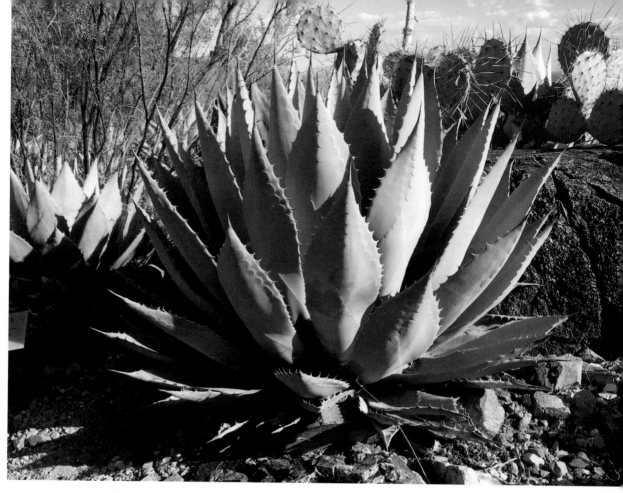

Above — Leaves of species in the *Agave* group of agaves are noted for their pronounced marginal armature, which helps protect them from predators.
PHOTO BY J. MOORE

Right — Leaves of species in the *Littaea* group of agaves are noted for minimal marginal armature. PHOTO BY J. MOORE

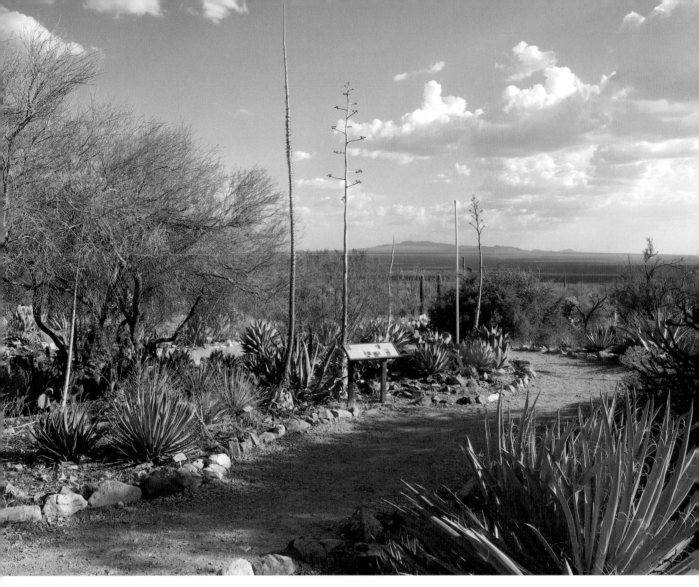

Above — Standing stalks of each subgenus are displayed in the Agave Garden. PHOTO BY J. MOORE

Left — Blue agave and Murphy's agave, seen here side by side, represent current and historical beverage and food use plants. PHOTO BY J. MOORE

Visitors to the garden are offered close views of each species—the leafy base, towering flower stalks, and magnificent flowers. Plants flower regularly, allowing visitors to see various types of inflorescences. Visitors will also find a "living quiz," with displays of three similar, yet unrelated plants: cactus, yucca, and aloe; an agave is included for comparison. This garden is a wonderful educational opportunity for the incipient agave enthusiast!

The "agave cactus," *Leuchtenbergia principis*, has highly developed tubercles, giving it an agave-like appearance, but it is actually a cactus from Mexico. PHOTO BY J. MOORE

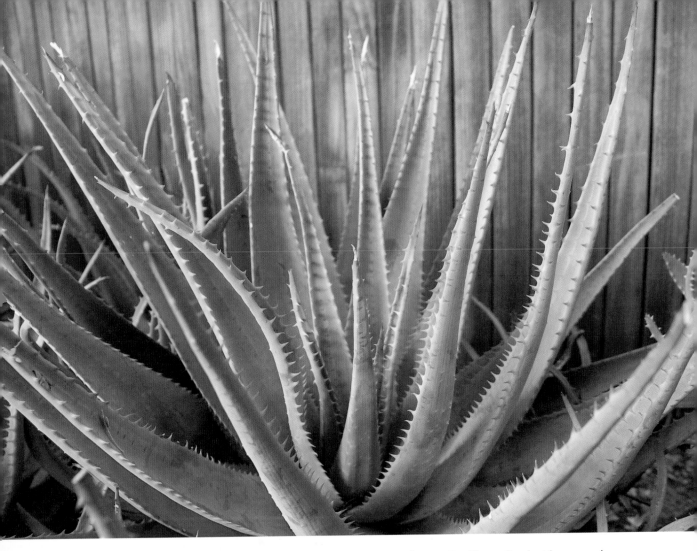

Above — Readily confused with agaves, aloe leaves are not as sharp tipped as agaves.

PHOTO BY J. MOORE

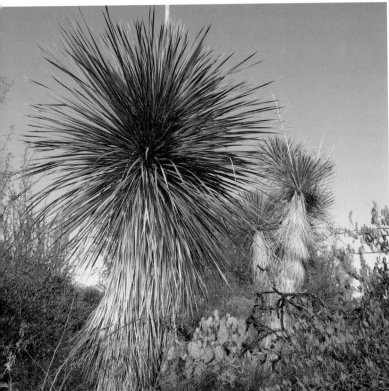

Left — With long pointed leaves, yuccas are often confused with agaves; however, most yuccas have prominent stems and are less succulent.

PHOTO BY J. MOORE

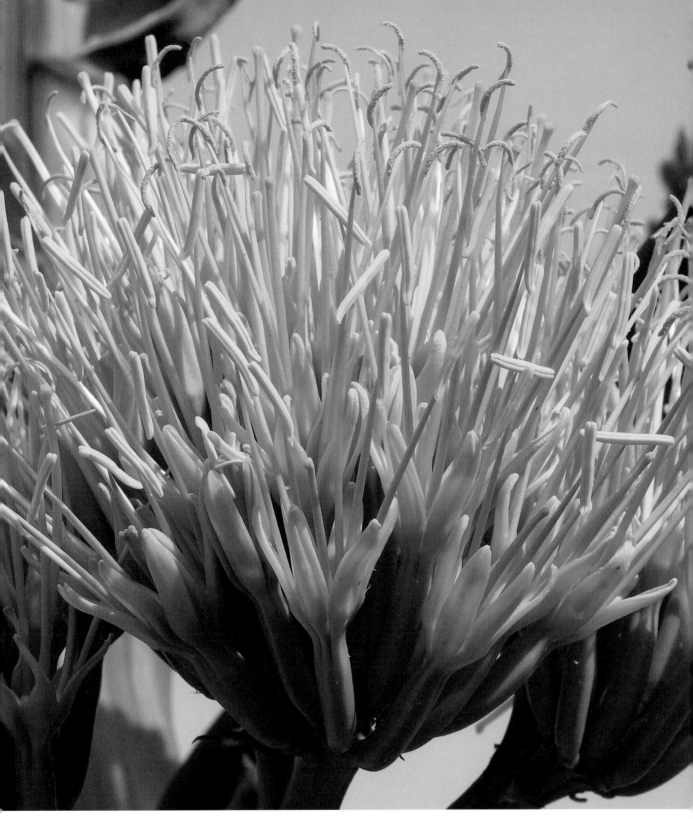

The flowers of Shaw's agave (*Agave shawii*) offer nectar to pollinators and beauty to the eye of the beholder.
PHOTO BY K. BAKER

Agaves are distinguished by their hard marginal teeth and stiff-tipped, succulent but fibrous leaves. PHOTO BY J. MOORE

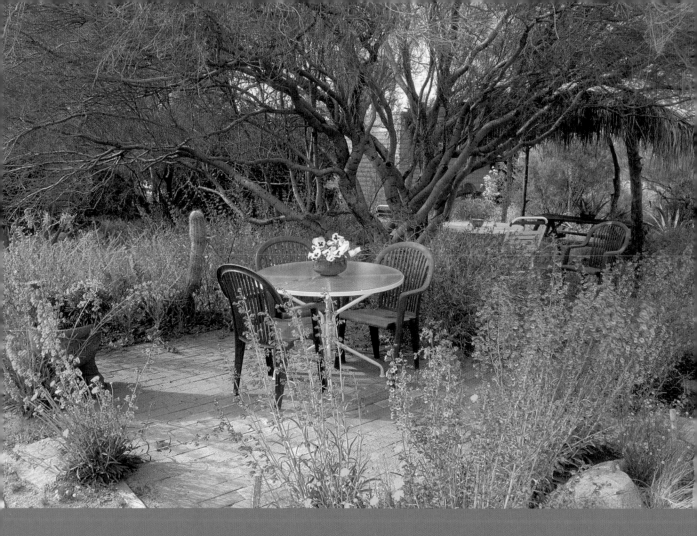

Growing Native

BY JOHN F. WIENS AND JULIE HANNAN WIENS

A native garden can bring natural wonders to your doorstep. Gardening with native plants is beneficial to wildlife, environmentally sustainable, and more easily maintained than exotic gardens, and it reduces the likelihood of introducing invasive non-native plants to the area. But like any successful garden, native gardens require good stewardship, which in turn requires basic knowledge of local natural habitats.

In the last century, thousands of plant species from the Old World have been introduced in the United States for gardening, landscaping, or agricultural purposes. Although many are harmless and pleasing, many others now threaten native plants and wildlife throughout the Southwest. Lacking the natural checks and balances of their homeland, some of these non-natives, or exotic species, have spread from our residential yards into the natural environment, where they have displaced our native species. In this chapter, we present some of the most egregious offenders and offer safe alternatives for your landscape or garden.

Many invasive plants arrived accidentally. Tumbleweed (Russian thistle) seeds arrived in North America inadvertently mixed with flax seeds shipped from Russia in 1874. Sahara mustard was also an accidental introduction. However, some of our worst invasives were intentionally introduced for presumed agricultural benefits. One is Johnsongrass, which was introduced as a potential forage crop in the early 1800s. Lehmann lovegrass was introduced as an ill-conceived means of restoring depleted rangelands in the 1930s. Buffelgrass, which is the current bane of the Southwest, is another Old World species introduced to Australia and the Sonoran Desert Region as forage for cattle; buffelgrass has become one of the most dreaded pests in both places, where it is capable of out-competing nearly all of the native plant species. Salt cedar, introduced to control wind-caused soil erosion in the 1800s, is now taking over riparian habitats throughout the United States Sunbelt.

Opposite — A garden of Sonoran Desert native plants can be colorful. PHOTO BY T A. WIEWANDT

This Tucson hillside has been invaded by fountaingrass. PHOTO BY J. F. WIENS

COMMON INVASIVE PLANTS AND SOME NATIVE ALTERNATIVES

The Culprit. Fountaingrass, a native to North Africa, the Middle East, and southwest Asia, arrived in the Sonoran Desert region in the early twentieth century. Sold in nurseries, it quickly became a popular landscape plant, escaped from cultivation, and now chokes roadsides and desert canyons in several states. Fountaingrass is extremely invasive; *it has no place in gardens or landscapes.*

The Alternative. Native grasses like sacaton, bull grass, and deer grass can fill the same aesthetic niche as fountaingrass. Sacaton grows as a large bunch, flaunting long graceful flower stalks from June to October. Bull grass has dense, blue-green foliage topped with dark purple flower spikes that decorate the plant in the fall. Deer grass is a great specimen plant or textural accent. It is a large, dark green bunch grass that sends up long flower spikes from July to October. These alternatives, like many grasses, soften the look of a landscape and attract wildlife.

The Culprit. Vinca or bigleaf periwinkle is another problematic escapee in the Sonoran Desert region. This attractive ornamental groundcover was introduced to the nursery trade from the Mediterranean region. In the average desert landscape it is fairly benign. However, when located near sensitive stream habitats it becomes aggressively invasive. It is now found in the moist soils of desert canyons throughout the Southwest.

Vinca is difficult to contain in moist environments. PHOTO BY M. A. DIMMITT

The Alternative. A colorful native species, such as hummingbird trumpet, would do well in your garden in place of vinca. With reddish orange tubular flowers, it does well in shade and sun and requires much less moisture than vinca. Another good substitute for vinca is the native four o'clock (Colorado or desert four o'clock)—a vigorous, tuberous plant that lies dormant in the winter and sprouts trailing stems of lush blue-green leaves in the spring. Its beautiful pink, tubular flowers open in the afternoon and stay open until the next morning. It will drape over walls and rock, and attracts hummingbirds, hawkmoths, and birds. Another good plant for

groundcover is Mexican skull cap, a diminutive substitute for vinca. This native purple-flowered plant, a relative of the snapdragon, does well in the same situations as vinca.

The Culprit. An arid-land tree of South Africa, African sumac was introduced to Tucson in the 1920s by the landscape industry. The wind carries its highly allergenic pollen from November to February. Once established along a wash or roadside, it spreads quickly, and since its canopy produces very deep shade it tends to crowd out native species. With an invasive and deep root system, this species is hard to remove.

The Alternative. Good alternatives for African sumac trees are desert willow, velvet and honey mesquites, and netleaf hackberry. Desert willow is a fast-growing smaller tree with a willowlike appearance. A profusion of large, white-to-deep-purple flowers grace the tree all summer and sometimes into fall. Native mesquites (*Prosopis velutina* and *P. glandulosa*) can have wonderful branching habits. Using minimal water, these trees produce a more open canopy that allows other plants to grow beneath them. Netleaf hackberry has higher water needs than mesquites but grows larger, to 30 feet tall. It has gray bark with an interesting texture and branches with a curious twisting habit. Birds enjoy its reddish orange berries in the fall.

The Culprit. Introduced primarily as a windbreak, the giant reed is a tall, ornamental cane. Giant reed is among the fastest growing terrestrial plants in the world, and it is outcompeting willows and other natives in the riparian ecosystems of the Southwest.

The Alternative. For your garden, arrowweed and seepwillow are acceptable native alternatives to giant reed. Though shorter, arrowweed

grows tall enough (6 to 8 feet) to serve as a visual screen. It has soft, shimmering gray foliage and small, lavender flowers from March through July. Seepwillow is a multistem plant up to 10 feet tall. It bears fuzzy, white-to-pink flowers from spring through summer. Birds and insects, including many butterfly species, are strongly attracted to seepwillow.

The Culprit. Another popular ornamental to avoid is pampas grass, which *forms dense stands that can exclude other plants and become a fire hazard*.

The Alternative. Consider, instead, the native grasses mentioned earlier, as well as bamboo muhly. Bamboo muhly grows from 2 to 6 feet tall and is a lacy, graceful plant. It flowers with feathery panicles in the

Giant reed, an invasive exotic plant, is growing in the Santa Cruz Riverbed in Tucson.
PHOTO BY J. F. WIENS

Russian olive infests roadsides and streambeds in high desert areas. PHOTO BY J. H. WIENS

winter and spring and makes an attractive statement whether planted singly or in masses.

The Culprit. The introduced ornamental ravenna grass, with plumes resembling those of pampass grass, is also spreading into wild habitat.

The Alternative. Good alternatives for ravenna grass include the beargrasses. While not true grasses, these Southwest natives have the same growth forms. Texas beargrass is an attractive "bunch grass" with evergreen leaves over 2 feet tall. In spring and early summer, long clusters

|

of creamy white flowers adorn this plant. Another variety of beargrass, common in grasslands and oak woodlands of the Southwest, is sotol chiquita, which has long, slender glossy green leaves. Also, consider large true grasses such as sacaton (described previously).

The Culprit. Russian olive is an invasive species that has crowded out many of the native riparian trees in the Southwest. Russian olive was introduced to the United States in the late 1800s. Widely planted as a hardy ornamental in Arizona, it is still sold in some nurseries. This thorny shrub or tree interferes with natural plant succession and nutrient cycling, and taxes soil water reserves.

The Alternative. In your landscape, a native plant such as yewleaf willow would serve as well. It is a medium-sized tree with small leaves of a gray, silvery cast. Arrowweed is another good alternative, as is Texas mountain laurel—a beautiful, dense shrub or small multi-trunked tree with clusters of scented purple flowers in early spring. Another option is Goodding willow, a large tree with long, narrow green leaves. Large yards might accommodate an Arizona ash, which reaches 30 to 50 feet tall. In the fall, its rounded canopy of glossy green leaves turns golden before the tree goes dormant.

Siberian elm is an invasive tree found throughout the Southwest.
PHOTO BY R. R. OLD

The Culprit. Siberian elm is a fast-growing tree from the Far East. It, too, was introduced in the late 1800s for windbreak and ornamental purposes. It now "volunteers" in Arizona and several other Western states.

The Alternative. Netleaf hackberry and velvet ash are

African daisy, an exotic invasive plant, spreads aggressively during wet winters. PHOTO BY JOSEPH M. DITOMASO, UNIVERSITY OF CALIFORNIA-DAVIS, BUGWOOD.ORG

good native alternatives for Siberian elm, as are native oaks. Structurally handsome, oaks create great shade and add appeal to almost any landscape.

The Culprit. Even pretty flowers can be highly, and detrimentally, invasive. African daisy is a cool-weather, non-native annual wildflower that reseeds readily. It is persistent in dry, disturbed areas and is now seen throughout Southern California and Arizona, usually near developed or landscaped areas.

The Alternative. If you want to sow wildflower seeds, please use the native species that occur in your region.

The Culprit *with* an Alternative. Finally, there is the interesting case of desert broom as a "native invasive." Although often considered a pest of disturbed ground locally, this fast-growing evergreen shrub *is a Sonoran Desert native. In its natural, low-desert range, desert broom can be useful, but landscapers, contractors, and retailers should stock and distribute only non-seed producing (male) cloned plants to help to avoid excessive or unnatural distribution.*

The challenge of sustainable gardening, of "growing native," is selecting plants appropriate to your region. Use the Internet to research what is native to and has the same growing requirements of your zone. Be careful to avoid known invasive plant species. Look to the expertise of your local native plant society for guidance in your plant selections. Ethically, every nursery should do its part to ensure that the species it sells are environmentally friendly (and reminding your local nursery managers of this is good politics!). Nurseries belonging to the Arizona Nursery

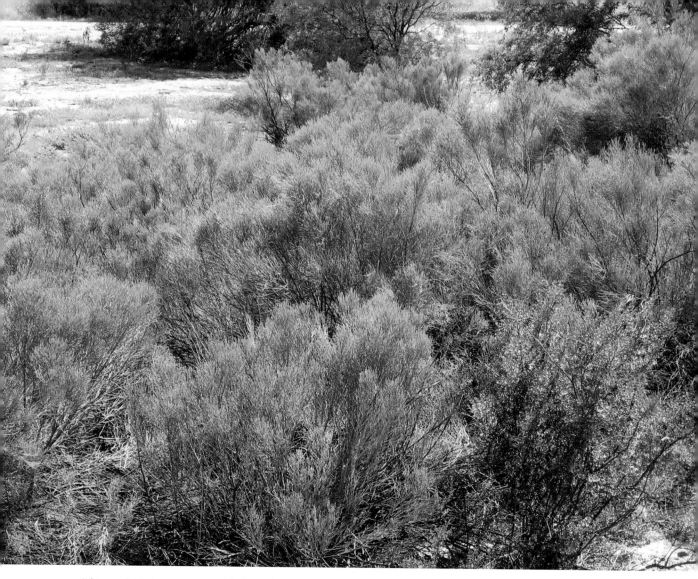

This roadside is overgrown with desert broom. PHOTO BY J. F. WIENS

Association (ANA) have adopted the national Voluntary Code of
Conduct for Nursery Professionals. This endorses the idea that each
new plant should be evaluated for potential invasiveness. When visiting
your local nurseries look for and request specific regional species. If the
nurseries do not have them in stock, your request may encourage them to
research and stock them.

Trustworthy Native Plants for Southwestern Gardening

BY JOHN F. WIENS, JULIE HANNAN WIENS,
AND DANIEL ARMENTA

Nurseries and botanical gardens do a lot of the legwork for the
home gardener, but trial and error is the only sure way to test
the value of a species in a particular setting. For as long as the
Desert Museum has been around, our botanists have been immersed in
horticultural experimentation, entailing much trial and error. Over many
years of exploring the Sonoran Desert Region and trying new plants
on our grounds, we have discovered some winners for desert gardens.
However, successfully introducing a new plant to horticulture is difficult.

It requires significant promotion to generate public awareness, and supply and demand must develop together or the introduction will fail. Some of our discoveries have caught on, some have not, and some just need a second chance.

This chapter describes those plant discoveries that have flourished in Desert Museum gardens. Under **Success Stories**, we describe the species that have become very popular in local gardens with the help of other growers. Under **Limited Popularity and Availability** we present plants that do well here and are not invasive, but for one reason or another have not gained as much popularity. As a result, they are not often grown by nurseries and can be hard to find. The **Unknown By Most** section introduces plants that we have grown at the Museum with great success and have sold in our own plant sales, but that are nearly impossible to find elsewhere. We hope that we can eventually add them to our list of successful introductions.

SUCCESS STORIES

'Desert Museum' palo verde. This complex hybrid palo verde (*Parkinsonia aculeata* × *P. microphylla*) × *P. florida*) was bred for the Desert Museum in 1980 by Dr. Mark Dimmitt. It combines the best traits of its parents: fast growth, large flowers, upright habit, and smaller, less messy leaves. It has two additional desirable traits not found in any of the parent species: a very long flowering season and no thorns. Both flowers and green bark have deeper hues and greater brilliance. Look for these beautiful trees framing the entrance to the Desert Museum and in landscapes throughout the Southwest.

Opposite — 'Desert Museum' palo verde (*Parkinsonia aculeata* × *P. microphylla* × *P. florida*).
PHOTO BY J. H. WIENS

Baja fairyduster (*Calliandra californica*). This desert-adapted legume from Baja California grows to 6 feet tall. Profuse red starburst flowers decorate the plant from March through November in response to watering or rainfall, providing an excellent nectar source for butterflies and hummingbirds. First brought under cultivation decades ago by Warren Jones, this species is still a star of desert landscaping.

For people who enjoy their gardens in the cool mornings and evenings, **tufted evening primrose** (*Oenothera caespitosa*) is an exceptional plant. It is an evergreen perennial with large, vividly white, fragrant flowers that bloom from late winter into spring, and again in the fall, opening at sunset and staying open until midmorning.

Top — Baja fairyduster (*Calliandra californica*).
PHOTO BY D. ARMENTA

Bottom — Tufted evening primrose (*Oenothera caespitosa*).
PHOTO BY K. DUFFEK

Limited Popularity and Availability

Velvet mesquite (*Prosopis velutina*) is often passed over by landscapers for "Chilean" mesquite species and hybrids from South America. However, the native velvet mesquite has stronger wood (less chance of splitting), better rooting (doesn't blow over in storms like its southern cousins), and (in our opinion) a more picturesque form. Unfortunately, the South American mesquites can hybridize with this native and seed stock is becoming tainted. We feel a push should be made to "reintroduce" it, in its pure form.

White-bark acacia (*Acacia willardiana*) is an elegant species endemic to the foothill desert and thornscrub of Sonora, Mexico. This small tree has a striking silhouette with slender arching branches and white bark that peels off in papery sheets. In early summer, cylindrical spikes of ivory flowers seem to hang in midair from the tenuous twigs. Though fast growing, the upright form and small mature size makes white-bark acacia a great choice for a small yard or narrow planter. Fortunately, it is becoming more available in nurseries.

Another great tree for patios or tight areas is the **western soapberry** (*Sapindus drummondii*), a small deciduous tree resembling an ash or walnut. The tiny white flowers are followed by marble-sized, translucent yellow berries in late summer to fall. Native to grasslands, cliffs, and canyons of the Southwest, it is also winter-hardy.

Top — Velvet mesquite (*Prosopis velutina*). PHOTO BY J. F. WIENS

Bottom — White-bark acacia (*Acacia willardiana*). PHOTO BY D. ARMENTA

Palms have long been a staple of "oasis in the desert" landscapes. The trick is to find a species that is frost hardy, less water consumptive, and stays in scale with the home landscape. At the Museum, **babiso palm** (*Brahea brandegeei*, syn. *B. elegans*) has proven itself in those regards. Native to moist canyons in the desert hills of Sonora and Baja California, this striking palm works well with the mini-oasis garden motif.

Desert lavender (*Hyptis emoryi*, syn. *H. albida*) is an attractive medium-sized shrub with felty, aromatic, blue-gray foliage. It is found across the Sonoran Desert in arroyos and canyons. Several times a year it produces multitudes of small purple, lavender-scented flowers. It is a reliable source of nectar for many desert butterflies and hummingbirds and an abundant source of pollen for various bees.

Above — Western soapberry tree (*Sapindus drummondii*). PHOTO BY M. A. DIMMITT

Left — Babiso palm (*Brahea brandegeei*, syn. *B. elegans*). PHOTO BY D. ARMENTA

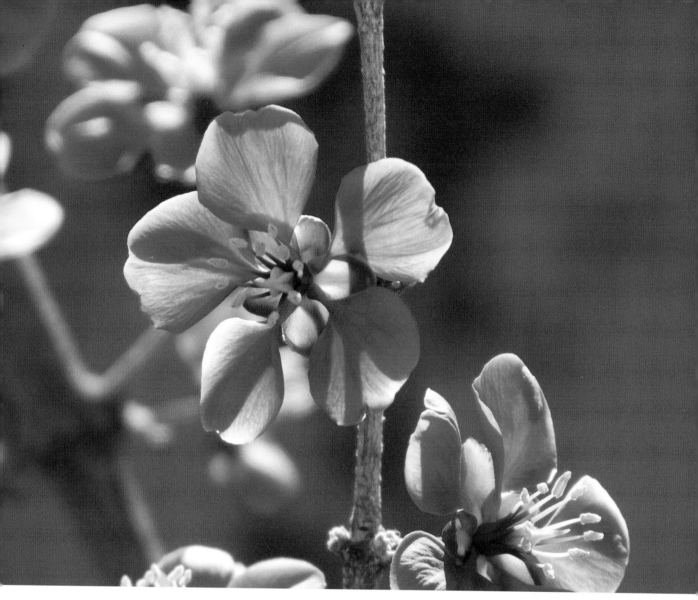

Above — Guayacán (*Guaiacum coulteri*).
PHOTO BY K. BAKER

Right — Desert lavender (*Hyptis emoryi*,
syn. *H. albida*). PHOTO BY D. ARMENTA

Guayacán (*Guaiacum coulteri*) is a woody shrub with a zigzag branching structure and vivid green foliage. One-inch blossoms of deep blue-violet cover the plants in May. This is a rare color in the desert—candy to the eye of a plant lover. The golden-orange fruit splits open to reveal seeds covered with rich red pulp. Guayacán is native to the plains and foothills of southern Sonora and Sinaloa, Mexico.

Palo prieto (*Senna polyantha*, syn. *S. goldmannii*). This airy, semi-deciduous large shrub from Baja California makes a great background or screening plant.

Small, light green leaves on contrasting reddish twigs give the plant a striking copper color, while masses of bright yellow flowers blanket it in summer. Larvae of sulphur butterflies, including the cloudless sulphur, feed on the tips of this plant.

Baja red is a variant of the popular, pink-flowered queen's wreath (*Antigonon leptopus*) with deep coral to crimson flowers. In southwestern gardens this vigorous vine from Baja California usually dies to the ground in winter, resprouting from thick roots each spring. From June to November it blooms profusely,

Above — Palo prieto (*Senna polyantha*, syn. *S. goldmannii*).
PHOTO BY M. A. DIMMITT

Left — Baja red queen's wreath (*Antigonon leptopus*).
PHOTO BY M. A. DIMMITT

attracting butterflies such as blues, hairstreaks, and the queen butterfly.

Native to the hottest, driest habitats of the Sonoran Desert, **Sonoran nightshade** (*Solanum hindsianum*) is an open shrub with soft gray leaves and an occasional thorn. It bears gorgeous, lavender, star-shaped flowers year-round in frost-free locations. Bumblebees and carpenter bees buzz-pollinate the flowers, and sphinx moths sip its nectar in evening and early morning hours.

Sonoran nightshade (*Solanum hindsianum*).
PHOTO BY J. F. WIENS

Unknown by Most

Creosotebush (*Larrea divaricata tridentata*) is the most common desert shrub and the most drought tolerant perennial plant in North America. A distinctive form called **dune creosotebush** (*Larrea divaricata* var. *arenaria*) grows naturally only in part of the Algodones Dunes in southeastern California. Some plants of this variant will be only 2 feet wide when they are 12 feet tall, and can reach 20 feet—the growth form of Italian cypress! The shiny, aromatic leaves are evergreen except during the worst droughts. Its yellow flowers appear after rains or irrigation. Once established, it needs no care whatsoever.

Wild cotton (*Gossypium turneri*) is a robust, mounding shrub to 6 feet tall with thick, glossy, dark green leaves. The butter-yellow flowers with bright red nectar guides adorn this plant from May through September and can even continue through December. Although very deserving, this species is rarely ever seen in horticulture. It is native to the coast in

Top — Dune creosote-bush (*Larrea divaricata* var. *arenaria*).
PHOTO BY D. ARMENTA

Bottom — Yellow morning glory vine (*Merremia aurea*).
PHOTO BY M. A. DIMMITT

Sonora, Mexico, and southern Arizona.

Yellow morning glory vine (*Merremia aurea*). This Baja California endemic woody vine grows rapidly up to 20 feet or more each year. All summer, and into the fall, it bears 2-inch, brilliant yellow flowers from which sulphur butterflies and carpenter bees drink nectar. In southern Arizona it usually freezes to the ground in the winter, but this scarcely sets it back, as it resprouts readily in the spring. For a dazzling color combination, plant with Baja red queen's wreath.

Arizona milkweed, (narrowleaf milkweed) (*Asclepias angustifolia*) is a compact sub-shrub that Museum botanists discovered growing in the understory of the pine-oak forests of the Sierra Madre Occidental in Sonora, Mexico. It is fast growing, mounding to about 2 feet, with evergreen, narrow, linear leaves. It readily blooms from spring until the first frost. Clusters of white flowers at the ends of the stems attract many butterflies, including the queen and monarch whose larvae (caterpillars) feed on the plant. It is an excellent addition to a pollinator garden

or simply as an accent plant. It has proven very suitable to the Museum's desert gardens.

Rock trumpet (*Telosiphonia brachysiphon*) produces an abundance of fragrant, white, trumpet-shaped flowers 2 inches long and nearly as wide from spring through summer. Conspicuous even in dim light, the flowers open at dusk and

Above — Wild cotton (*Gossypium turneri*).
PHOTO BY J. F. WIENS

Left — Arizona milkweed, also called narrowleaf milkweed (*Asclepias angustifolia*).
PHOTO BY J. F. WIENS

remain open much of the next day. Rock trumpet grows in grasslands in southeastern Arizona and adjacent Sonora, usually in rock crevices. This plant is difficult to propagate, but its beauty is worth extra effort.

Teabush (*Melochia tomentosa*) is a small shrub that goes almost unnoticed until it blooms in the summer, when its rich, lavender, half-inch flowers are abundant. Purple is not a very common flower color here, especially in the summer, so teabush can help diversify a garden's color palette. A native of the Sonoran Desert region, it attracts many species of butterflies with its nectar.

Nacapule jasmine (*Vallesia laciniata,* syn. *V. baileyana*) is the perfect plant for a mini-oasis in a Xeriscape garden. Its tiny white flowers, abundant in the summer and fall, exude a rich jasmine fragrance and its dense, deep green leaves make it an excellent screen or background plant. Large and evergreen, it can add a lush, soft facet to an otherwise harsh desert landscape.

Though seen only occasionally in southwestern gardens, **Mexican tree sunflower** (*Tithonia fruticosa*) is an absolutely striking plant when in full flower. This woody perennial grows rapidly to over 10 feet tall and

Top — Nacapule jasmine
(*Vallesia laciniata*).
PHOTO BY M. A. DIMMITT

Bottom — Rock trumpet
(*Telosiphonia
brachysiphon*).
PHOTO BY J. F. WIENS

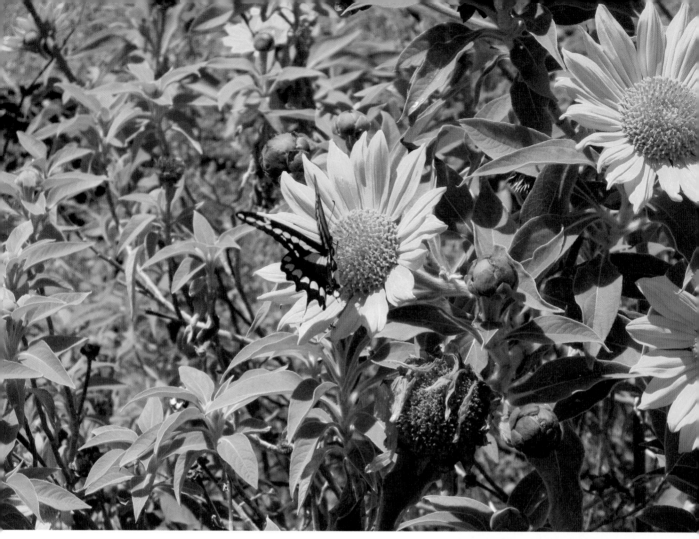

Above — Mexican tree sunflower (*Tithonia fruticosa*). PHOTO BY K. BAKER

Right — Teabush (*Melochia tomentosa*). PHOTO BY D. ARMENTA

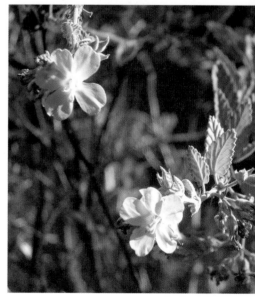

nearly as wide. It produces a profusion of 4-inch, bright yellow flowers in spring (or summer, if it has frozen to the ground in winter). A large, mature plant can have fifty or more flowers at once. Attractive to butterflies, it should not be overlooked for a pollinator garden.

False grama (*Cathestecum brevifolium*) is a fine-textured, warm-season grass common from the desert floor

Left — False grama (*Cathestecum brevifolium*). PHOTO BY J. F. WIENS

Below — Mezcal pelón (*Agave pelona*). PHOTO BY D. ARMENTA

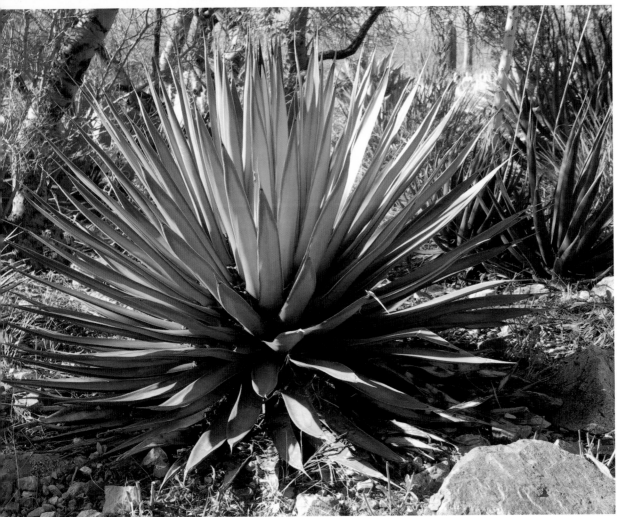

DESERT GARDENS

to the tropical deciduous forests of Sonora, Mexico. In the United States, it is found only in the Ironwood Forest National Monument, near Tucson. Dormant in the winter, false grama greens up as early as April if watered. It is a graceful, arching miniature bunch grass, mounding to less than 1 foot tall. A larval food for orange and fiery skippers, it is also eaten by desert tortoises.

Unlike most agaves, **mezcal pelón** (*Agave pelona*) has burgundy-red blooms that attract hummingbirds. It is truly striking to see the 10- to 15-foot unbranched stalk covered in red blooms. This agave has no teeth or shredding leaf margins, but it *is* armed. Its rich, green leaves transition to purple tips with a stout, whitish terminal spine that is very sharp. It reaches 2 to 3 feet across at maturity (about twenty years). Mezcal pelón is native to a few limestone mountain ranges in northwestern Sonora, Mexico.

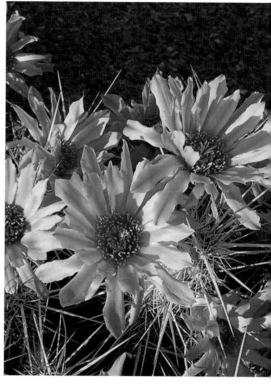

Baja strawberry hedgehog (*Echinocereus brandegeei*). PHOTO BY M. A. DIMMITT

Baja strawberry hedgehog (*Echinocereus brandegeei*). While nearly all other hedgehog cacti flower in spring, Baja strawberry hedgehog blooms for a month between late June and September. Its 3-inch, ruffled flowers are brilliant magenta or deep pink with red centers. The clumping stems start out erect, but may lie down and trail for a foot or more, and the plant looks great in containers, hanging pots, or in rock gardens. It is native to the Vizcaíno area in central Baja California.

Plant Names Used in This Book

TREES

*African sumac (*Rhus lancea*)

Arizona ash (*Fraxinus velutina*)

Arizona black walnut (*Juglans major*)

Arizona sycamore (*Platanus wrightii*)

Brazil tree (*Haematoxylum brasiletto*)

canyon hackberry (*Celtis reticulata*)

desert ironwood (*Olneya tesota*)

desert willow (*Chilopsis linearis*)

elephant trees (*Bursera* spp.)

feather tree (*Lysiloma watsonii*)

Fremont cottonwood (*Populus fremontii*)

Goodding willow (*Salix gooddingii*)

honey mesquite (*Prosopis glandulosa*)

Mexican elder (*Sambucus mexicana*)

netleaf hackberry, aka canyon hackberry (*Celtis reticulata*)

oaks

 Mexican blue oak (*Quercus oblongifolia*)

 Emory oak (*Quercus emoryi*)

hesper palms

 Babiso palm, aka palma palmía or blue palm
(*Brahea brandegeei*, syn. *B. elegans*)

 Sonoran hesper palm, aka blue palm (*Brahea aculeata*)

palo verde trees

 blue palo verde (*Parkinsonia florida*)

 'Desert Museum' palo verde (*Parkinsonia aculeata*

X *P. microphylla*) X *P. florida*

 foothills palo verde (*Parkinsonia microphylla*)

rock fig (*Ficus petiolaris*)

*Russian olive (*Elaeagnus angustifolia*)

*Siberian elm (*Ulmus pumila*)

Texas ebony (*Ebenopsis ebano*; formerly *Pithecellobium flexicaule*)

velvet ash (*Fraxinus velutina*)

velvet mesquite (*Prosopis velutina*)

western soapberry tree (*Sapindus drummondii*)

white-bark acacia (*Acacia willardiana*)

yewleaf willow (*Salix taxifolia*)

SHRUBS, GROUNDSCOVERS, VINES, AND WILDFLOWERS

*African daisy (*Dimorphotheca sinuata*)

Arizona rosewood (*Vauquelinia californica*)

arrowweed (*Pluchea sericea*)

Baja fairyduster, Baja red fairyduster (*Calliandra californica*)

Baja red queen's wreath (*Antigonon leptopus*)

bat-face flower (*Cuphea llavea*)

big sagebrush (*Artemisia tridentata*)

bird of paradise (*Caesalpinia*)

red bird of paradise (*C. pulcherrima*)

 Mexican bird of paradise (*C. mexicana*)

blue butterfly mist (*Ageratum corymbosum*)

brittlebush (*Encelia farinosa*)

desert ceanothus (*Ceanothus greggii*)

chocolate flower (*Berlandiera lyrata*)

chuparosa (*Justicia californica*)

Colorado, or desert, four o'clock (*Mirabilis multiflora*)

coral bean (*Erythrina flabelliformis*)

coral bells (*Heuchera sanguinea*)

creosotebush (*Larrea divaricata* subsp. *tridentata*)

 dune creosotebush (*Larrea divaricata* var. *arenaria*)

desert broom (*Baccharis sarothroides*)

desert chicory (*Rafinesquia neomexicana*)

desert hackberry (*Celtis pallida*)

desert honeysuckle (*Anisacanthus thurberi*)

desert lavender (*Hyptis emoryi*)

desert marigold (*Baileya multiradiata*)

desert mistletoe (*Phoradendron* spp.)

desert rose-mallow (*Hibiscus coulteri*)

devil's claw (*Proboscidea parviflora*)

 tropical devil's claw (*P. parviflora* subsp. *sinaloensis*)

evening primroses

 Hooker's evening primrose (*Oenothera hookeri*)

 tufted evening primrose (*Oenothera caespitosa*)

 yellow evening primrose (*Calylophus hartwegii*)

fairyduster (*Calliandra eriophylla*)

fern acacia (*Acacia angustissima*)

flattop buckwheat (*Eriogonum fasciculatum*)

globemallow (*Sphaeralcea* spp.)

golden columbine (*Aquilegia chrysantha*)

golden fleece (*Thymophylla pentachaeta*)

guayacán (*Guaiacum coulteri*)

hechtias (*Hechtia* spp.)

hopbush (*Dodonaea viscosa*)

hummingbird trumpet (*Epilobium canum* ssp. *latifolium*)

jimson weed, sacred datura (*Datura wrightii*)

jojoba (*Simmondsia chinensis*)

lantana (*Lantana camara, L. montevidensis,* and others)

lizard's tail (*Anemopsis californica*)

longleaf morning glory (*Ipomoea longifolia*)

lupine (*Lupinus* spp.)

Mexican cardinal flower (*Lobelia laxiflora*)

Mexican skull cap (*Scutellaria potosina* var. *tessellata*)

Mexican tree sunflower (*Tithonia fruticosa*)

milkweeds

 Arizona, or narrowleaf milkweed (*Asclepias angustifolia*)

 desert milkweed (*Asclepias subulata*)

 giant cane milkweed (*Asclepias albicans*)

 pineleaf milkweed (*Asclepias linaria*)

Nacapule jasmine (*Vallesia laciniata,* syn. *V. baileyana*)

palma de la vírgen (*Dioon edule*; a cycad)

palo prieto (*Senna polyantha,* syn. *S. goldmannii*)

paperflower (*Psilostrophe cooperi* and *P. tagetina*)

Parry's penstemon (*Penstemon parryi*)

passion vine, passion flowers (*Passiflora bryonioides,* and others)

phacelias (*Phacelia* spp.)

pink gaura (*Gaura lindheimeri*)

pipevine plant (*Aristolochia* spp.)

poppies

 California poppy (*Eschscholzia californica* ssp. *californica*)

 Mexican gold poppy (*Eschscholzia californica* ssp. *mexicana*)

rock trumpets (*Telosiphonia brachysiphon* and *T. nacapulensis*)

*Sahara mustard (*Brassica tournefortii*)

*saltcedar (*Tamarix ramosissima*)

salvias

 Mexican bush sage (*Salvia leucantha*)

 Maycoba sage (*Salvia betulifolia*)

 purple sage (*Salvia dorrii* var. *dorrii*)

 red sage (*Salvia greggii*)

scarlet sage (*Salvia splendens*)

 *Texas sage, blood sage, red salvia (*Salvia coccinea*)

 tropical sage (*Salvia misella* or *S. coccinea*)

sandpaper bush (*Mortonia scabrella*)

scarlet betony (*Stachys coccinea*)

scarlet monkeyflower (*Mimulus cardinalis*)

seepwillow (*Baccharis salicifolia*)

silverbells (*Streptanthus carinatus*)

snapdragon vine (*Maurandya antirrhiniflora*)

Sonoran justicia (*Justicia sonorae*)

Sonoran nightshade (*Solanum hindsianum*)

Sonoran spider lily (*Hymenocallis* sp.)

Syrian rue (Peganum harmala)

teabush (*Melochia tomentosa*)

Texas mountain laurel (*Sophora secundiflora*)

triangle-leaf bursage (*Ambrosia deltoidea*)

*tumbleweed, Russian thistle (*Salsola tragus*)

turpentine bush (*Ericameria laricifolia*)

verbena (*Verbena* spp. and *Glandularia* spp.)

*vinca, bigleaf periwinkle (*Vinca major*)

willow groundsel (*Senecio salignus*)

whitethorn acacia (*Acacia constricta*)

wild cotton (*Gossypium turneri* and others)

wolfberry (*Lycium brevipes* and others)

yellow morning glory vine (*Merremia aurea*)

yellow trumpet bush (*Tecoma stans*)

zinnias

 desert zinnia (*Zinnia acerosa*)

 prairie zinnia (*Zinnia grandiflora*)

CACTI

barrel cacti

 California fire barrel (*Ferocactus cylindraceus*)

 Emory barrel, Coville barrel (*Ferocactus emoryi*)

 fishhook barrel (*Ferocactus wislizeni*)

 Sonoran fire barrel (*Ferocactus gracilis*)

 golden-spined barrel cactus (*Ferocactus chrysanthus*)

chollas

 buckhorn cholla (*Cylindropuntia acanthocarpa*)

* Non-native invasive species; AVOID USING THEM IN GARDEN PLANTINGS

chain-fruit cholla, jumping cholla (*Cylindropuntia fulgida*)

pencil cholla (*Cylindropuntia arbuscula*)

Cylindopuntia molesta

hedgehogs (*Echinocereus* spp.)

Baja strawberry hedgehog (*E. brandegeei*)

golden hedgehog (*E. nicholii*)

organ pipe cactus (*Stenocereus thurberi*)

Pachycereus

etcho (*Pachycereus pectin-aboriginum*)

Pachycereus gatesii

senita (*Pachycereus schottii*)

peyote (*Lophophora williamsii*)

pincushion cacti (*Mammillaria* spp.)

Standley's mammillaria (*M. standleyi*)

prickly pears

Engelmann prickly pear (*Opuntia engelmannii*)

longspined prickly pear (*Opuntia macrocentra*)

Opuntia bravoana

desert night-blooming cereus, aka Arizona queen-of-the-night (*Peniocereus greggii*)

saguaro (*Carnegiea gigantea*)

sahuira (*Stenocereus montanus*)

Sonoran old man cactus (*Pilosocereus alensis*)

OTHER SUCCULENTS

agaves

chahuique (*Agave multifilifera*)

Huachuca agave (*Agave parryi huachucensis*)

mezcal pelón (*Agave pelona*)

octopus agave (*Agave vilmoriniana*)

Parry agave (*Agave parryi*)

Shaw's agave (*Agave shawii*)

beargrasses

beargrass, *sotol chiquita* (*Nolina microcarpa*)

Texas beargrass (*Nolina texana*)

Canary Islands spurge (*Euphorbia canariensis*)

desert spoon, *sotol* (*Dasylirion wheeleri*)

Fouquieria

ocotillo (*Fouquieria splendens*)

tree ocotillo (*Fouquieria macdougalii*)

boojum, cirio (*Fouquieria columnaris*)

Hesperaloes

night blooming hesperaloe (*Hesperaloe nocturna*)

red hesperaloe, red "yucca" (*Hesperaloe parviflora*)

true yuccas

Joshua tree (*Yucca brevifolia*)

soaptree yucca (*Yucca elata*)

slipper flower (*Pedilanthus macrocarpus*)

GRASSES

bamboo muhly (*Muhlenbergia dumosa*)

blue grama (*Bouteloua gracilis*)

*buffelgrass (*Pennisetum ciliare*)

bullgrass (*Muhlenbergia emersleyi*)

deergrass (*Muhlenbergia rigens*)

false grama (*Cathestecum brevifolium*)

*fountaingrass (*Pennisetum setaceum*)

*giant reed (*Arundo donax*)*

*Johnsongrass (*Sorghum halepense*)

*Lehmann lovegrass (*Eragrostis lehmanniana*)

*pampas grass (*Cortaderia selloana*)

*ravenna grass (*Saccharum ravenna*)

sacaton (*Sporobolus wrightii*)

tanglehead (*Heteropogon contortus*)

* Non-native invasive species; AVOID USING THEM IN GARDEN PLANTINGS

Resources on Desert Gardening

FOR NURSERIES IN YOUR AREA,
CHECK OUT: www.findnurseries.com

Arizona

Arizona-Sonora Desert Museum. 2021 N. Kinney Rd., Tucson, AZ 85743-8918. (520) 883-1380. www.desertmuseum.org

Arizona Native Plant Society. P.O. Box 41206, Sun Station, Tucson, AZ 85717. www.aznps.com

Boyce Thompson Arboretum. 37615 US Hwy 60, Superior, AZ 85273. (520) 689-2723. www.ag.arizona.edu

Desert Botanical Gardens. 1201 N. Galvin Parkway, Phoenix, AZ 85008. (480) 481-8134. www.dbg.org

Desert Legume Program. 2120 E. Allen Rd., Tucson, AZ 85719. (520) 318-7047. www.ag.arizona.edu/BTA/delep.html

Tohono Chul Park. 7366 N. Paseo del Norte, Tucson, AZ 85704. (520) 742-6455. www.tohonochulpark.org

Tucson Botanical Gardens. 2150 N. Alvernon Way, Tucson AZ 85712. (520) 326-9686. www.tucsonbotanical.org

University of Arizona Cooperative Extension. Tucson area: (520) 626-5161. Phoenix area: (602) 470-8086. ag.arizona.edu/extension

Yuma Conservation Garden. 2520 E. 32nd St., Yuma, AZ 85365. (520) 317-1935.

Southern California

Balboa Park, City of San Diego. 1549 El Prado, San Diego, CA 92101. www.balboapark.org

California Native Plant Society. 2707 K Street, Suite 1, Sacramento, CA 95816. (916) 447-2677. wwwcnps.org

Desert Water Agency. 1200 Gene Autry Trail, Palm Springs, CA 92264. (760) 323-4971. www.dwa.org

Huntington Botanical Gardens. 1151 Oxford Rd., San Marina, CA 91108. (626) 405-2100. www.huntington.org

Los Angeles Zoo and Botanical Garden. 5333 Zoo Dr., Los Angeles, CA 90027. (323) 644-4200. www.lazoo.org

Quail Botanical Gardens. 230 Quail Gardens Drive, Encinitas, CA 92023. (760) 436-3036. www.qbgardens.org

San Diego Zoo. Education Department, PO Box 120551, San Diego, CA 92112. (619) 234-3153. www.sandiegozoo.org

The Living Desert. 47-900 Portola Ave, Palm Desert, CA 92260. (760) 346-5694. www.livingdesert.org

The Theodore Payne Foundation. 10459 Tuxford St., Sun Valley, CA 91352. (818) 768-1802. www.theodorepayne.org

University of California Cooperative Extension. 2 Coral Circle, Monterey Park, CA 91755. (323) 838-8330. www.ucanr.org

Nevada

Las Vegas Springs Preserve. 333 S. Valley View Blvd., Las Vegas, NV 89153. (702) 822-7700. www.springspreserve.org

Nevada Native Plant Society. PO Box 8965, Reno, NV 89507. www.heritage.nv.gov/nnps.htm

New Mexico

Native Plant Society of New Mexico. P.O. Box 35388, Albuquerque, NM 87176. www.npsnm.unm.edu

New Mexico State University Cooperative Extension. Box 30003, MSC 3AE, Las Cruces, NM 88003. http://extension.nmsu.edu

Rio Grande Botanical Gardens. 2601 Central Ave. NW, Albuquerque, NM 87104. (505) 768-2000. www.cabq.gov/biopark/garden

Texas

Lady Bird Johnson Wildflower Center. 4801 La Crosse Ave., Austin, TX 78739. (512) 232-0100. www.wildflower.org

Native Plant Society of Texas. P.O. Box 3017, Fredericksburg, TX 78624-1929. (830) 997-9272. www.npsot.org

Texas A&M University Cooperative Extension Service. 1030 N. Zaragosa Rd., Suite A, El Paso, TX 79907. (915) 859-7725. http://texasextension.tamu.edu

Texas AgriLife Extension Service. 225 Horticulture/Forest Science Building, College Station, TX 77843-2134. (979) 845-8565. http://aggie-horticulture.tamu.edu

Publications

A Natural History of the Sonoran Desert. Steven J. Phillips and Patricia Wentworth Comus, editors. Arizona-Sonora Desert Museum Press, Tucson, AZ, with The University of California Press, Berkeley, CA. 2000

Arizona-Sonora Desert Museum, A Scrapbook. Peggy Pickering Larson. Arizona-Sonora Desert Museum Press. Tucson, AZ. 2002.

Arizona Gardener's Guide. Mary Irish. Cool Springs Press, Franklin, TN. 2001.

Bat House Builder's Handbook. Merlin D. Tuttle and Donna L. Hensley. Bat Conservation International. 1993. Distributed by University of Texas Press, Austin, TX.

Cool Plants for Hot Gardens. Greg Starr. Rio Nuevo Publishers, Tucson, AZ. 2009.

Creating Outdoor Classrooms, Schoolyard Habitats and Gardens for the Desert Southwest. Lauri Macmillan Johnson with Kim Duffek. University of Texas Press, Austin, TX. 2008.

Desert Butterfly Gardening. Arizona Native Plant Society and Sonoran Arthropod Studies Institute, Tucson, AZ. 1996.

The Desert Speaks. The Story of the Arizona-Sonora Desert Museum 1951 – 1979. William H. Carr. First - Fifth Editions, 1956 (reprinted 1979). Arizona-Sonora Desert Museum. Tucson, AZ.

Gardening in the Deserts of Arizona. Mary Irish. Cool Springs Press, Franklin, TN. 2008. One in a series of state-specific books.

The Hot Garden. Scott Calhoun. Rio Nuevo Publishers, Tucson, AZ. 2009.

Home in the Desert. Ann Woodin. The University of Arizona Press, Tucson, AZ. 1984.

How to Attract Hummingbirds and Butterflies. Ortho Books, San Ramon, CA. 1991.

How to Grow the Wildflowers. Eric A. Johnson and Scott Millard. Ironwood Press, Tucson, AZ. 1993.

In a Desert Garden: Love and Death Among the Insects. John Alcock. University of Arizona Press, Tucson, AZ. 1999.

Landscape Plants for Dry Regions. Warren Jones and Charles Sacamano. Fisher Books, LLC, Tucson, AZ. 2000.

Landscape Plants for Western Regions. Bob Perry. Land Design Publishing, Claremont, CA. 1992.

Landscaping for Desert Wildlife. Arizona Game and Fish Department, Phoenix, AZ. 1999.

Landscaping with Native Plants of Texas and the Southwest. George O. Miller. Voyageur Press, Inc., Stillwater, MN. 1991.

The Low-Water Flower Gardener. Eric A. Johnson, Don Fox (illustrator), and Scott Millard. Ironwood Press, Tucson, AZ. 1993.

Low Water Use Plants. Carol Schuler. Fisher Books, Tucson, AZ. 1993.

Mountain Islands and Desert Seas: A Natural History of the U.S.-Mexican Borderlands. Frederick R. Gehlbach. College Station, Texas A&M University Press. 1981.

Native Plants for Southwestern Landscapes. Judy Mielke, University of Texas Press, Austin, TX. 1993.

Native Texas Plants. Sally Wasowski and Andy Wasowski. National Book Network, Lanham, MD. 2000.

Pebbles in Your Shoes. William H. Carr. Arizona-Sonora Desert Museum, Tucson, AZ. 1982.

Sonoran Desert Spring. John Alcock. The University of Chicago Press, Chicago, IL. 1985.

Southwestern Landscaping with Native Plants. Judith Phillips. Museum of New Mexico Press, Santa Fe, NM. 1987.

Taylor's Guide to Gardening in the Southwest. Houghton Mifflin Company, Boston, MA. 1993.

The National Wildlife Federation's Guide to Gardening for Wildlife. Craig Tufts and Peter Loewer. Rodale Press, Emmaus, PA. 1995.

Waterwise Gardening. Sunset Publishing, Menlo Park, CA. 1989.

Glossary

angiosperm. A flowering plant; a group of plants whose seeds are borne in or on a mature ovary (fruit).

annual. Referring to a plant in which the life cycle, from seed germination to seed production, is completed in one growing season.

anther. The apical, pollen-bearing portion of the stamen.

arthropod. Member of the animal phylum Arthropoda. These animals are defined by their segmented bodies, joined appendages, and hard outer casing (exoskeleton). Examples are insects, crustaceans, spiders, centipedes, and millipedes.

awns. A bristle-like appendage, especially on bracts surrounding the flowers of grasses.

biome. A distinct region of the living environment, identified by a characteristic vegetation and maintained by local climatic conditions.

biota. The living species and individuals of an area, including plants, animals, microbes, fungi, etc.

bunchgrass. A grass that grows in clumps, new shoots arising from the crown.

coevolution. The adaptive evolution of two or more species that interact closely enough to create selective forces on each other.

community. Any ecologically distinct and integrated group of species of microorganisms, plants, and animals inhabiting a given area and physical environment.

composites. A family of plants (Asteraceae) characterized by inflorescences of individual flowers tightly clustered in disk-like heads (aka, the sunflower family).

deciduous. A term describing plants that shed leaves or branches seasonally or in response to drought, heat, cold, or other natural factors.

dioecious. Plants (and animals) having female and male reproductive elements on separate individuals.

diurnal. Active during daylight hours.

ecosystem. A community of plants, animals, and microorganisms that are linked by energy and nutrient flows and that interact with each other and with the physical environment. Rainforests, deserts, coral reefs, grasslands, and rotting saguaro cactus are all examples of ecosystems.

ephemeral. An event that lasts only a short time. A plant that grows, flowers, and dies in less than one season.

flora. The plants found in a given area.

guttation. The exudation of water droplets, caused by root pressure, in certain plants.

habitat. The place or environment where a plant or animal naturally lives and grows; a group of particular environmental conditions.

hybrid. Offspring of two different species or varieties.

hybridization. The production of a hybrid.

inflorescence. A cluster of flowers on a single stem (e.g., the panicle of penstemons, the spikes or panicles of agaves, the raceme of many lupines).

invertebrates. Animals without backbones.

larva (pl., larvae). An immature feeding stage of an animal that is different in appearance from the adult; metamorphosis is required to transform from larva (e.g., caterpillar) to adult (e.g., butterfly).

leguminous, legume. Being of a member of the bean family, *Fabaceae*.

Lepidoptera. The order of insects to which moths and butterflies belong.

microhabitat. A small, effectively isolated habitat within a larger ecosystem.

metamorphosis. The physical transformation of an animal from one life stage to the next.

monocarpic. A term describing plants that flower once and die.

native species. A species that occurs naturally in an area, and was not introduced there by humans.

naturalized. An organism that has become established in a new region, functioning as if native.

niche. The role played by a species in its ecosystem.

ovipositor. An organ used by some animals for egg laying.

panicle. A branched inflorescence bearing a cluster of flowers.

perennial. A plant that lives from year to year (as opposed to an annual, that lives for only a year or less).

pistil. The female reproductive part of a flower, usually differentiated into an ovary and a stigma (connected by a style).

pollen. The fertilizing particle of seed plants, containing the male gamete.

pollination. The process of transferring pollen from the anther to the receptive surface (stigma) of the ovary.

proboscis. Extendable, tubular mouthparts of an animal used for feeding.

pupa. The non-feeding, non-motile stage in metamorphic insects during which they transform from a larva to an adult.

rhizomatous. Producing horizontal underground stems (rhizomes) that root and produce shoots.

riparian. An area influenced by surface or subsurface water flows.

shrub. A woody plant smaller than a tree, with several main stems from the base rather than a single trunk.

spicate. Without branches (like a spike).

stamen. The pollen-producing organ of the flower.

stigma. In flowers, the receptive part of the pistil onto which pollen is deposited during pollination; generally situated at the top of the pistil.

stolon. A horizontal stem growing above ground, forming roots and shoots at nodes.

stomata. The gas-exchange pores in the epidermis of a plant (aka stomates).

succulent. Plants that have fleshy tissues that store and conserve moisture.

transpire. To give off water vapor through the stomata.

vertebrates. Animals with backbones.

Author Biographies

DANIEL ARMENTA has been with the Desert Museum since 2006. As a native of Tucson, he has long been passionate about the conservation of the Sonoran Desert. His love of plants began in childhood and has never wavered, even through his stint as a Political Science major at the University of Arizona. He has worked with a number of conservation-focused organizations including Native Seeds/SEARCH and the Tucson Audubon Society. His interest in for nature is shared by his wife Starlight and their son Oliver.

KIM BAKER is a Horticulturist at the Arizona-Sonora Desert Museum. He spent his formative years in northeastern Arizona, graduating from Arizona State University in 1978 with a Bachelor of Fine Arts degree. He initially worked as a printer and printer collaborator in the art of stone lithography, but it was cooking and an interest in native plant life that brought him to the Desert Museum. He first cooked in one of the Museum's dining venues, but shortly thereafter moved into the Botany Department. Kim enjoys hiking and drawing in Southern Arizona's Sky Islands mountains.

RICHARD C. BRUSCA is Senior Director for Science at the Arizona-Sonora Desert Museum, where he oversees all research and conservation programs. He is also a Research Scientist at the University of Arizona and an Adjunct Professor with Centro de Investigación en Alimentación y Desarrollo (CIAD, Sonora, Mexico). Rick is the author of more than one hundred and fifty research publications and fifteen books. His research interests include natural history and conservation of the Sonora Desert and the Gulf of California. He has organized and conducted research expeditions throughout the world and on every continent, but he has maintained his programs in the Sonoran Desert and the Gulf for more than thirty years. Rick is a Fellow in both the American Association for the Advancement of Science and the Linnean Society of London.

SCOTT CALHOUN is a fourth-generation Arizonan with a passion for the desert environment and desert-appropriate landscape design. *Zona Gardens* is one of his brainchildren, and *The Hot Garden: Landscape Design for the Desert Southwest* is his latest book.

GREG CORMAN is owner of *Gardening Insights*, a Tucson landscape design and consulting business. Greg spends a good deal of his time looking for new species for landscaping, or new ways to use traditional plants to create interesting and enjoyable gardens with an emphasis on low water use designs.

ELIZABETH DAVISON is Founding Director (and current Director) of the University of Arizona Campus Arboretum, and Lecturer at the University of Arizona, where she teaches courses in Horticulture. She is deeply devoted to the sustainable culture of healthy trees in Southwestern urban environments.

MARK A. DIMMITT has a Ph.D. in biology (herpetology) from the University of California at Riverside. He was Curator of Botany for his first eighteen years at the Desert Museum, and since 1997 he has been Director of Natural History in the Center for Sonoran Desert Studies at the Museum. His areas of research include botany and vertebrate biology, and he is the author of more than fifty scientific and popular publications about ecology and horticulture. He is a Fellow of the Cactus and Succulent Society of America. Mark's "other" career is as a plant breeder. He spent a couple of decades each hybridizing first *Trichocereus* (cacti), then *Tillandsia* (bromeliads); he has introduced about fifty cultivars. Since the late 1970s his main focus has been on breeding adeniums; 'Crimson Star', 'Evelyn Marie', and 'Bouquet' are among his creations. He is coauthor of the book *Adenium: Sculptural Elegance, Floral Extravagance*. Mark also collects and grows a number of other weird plants, mostly succulents and epiphytes.

KIM DUFFEK is a Horticulturist in the Desert Museum's Botany Department. She first came to Tucson from the Chicago area in 1981, to finish her degrees in wildlife ecology and studio art at the University of Arizona. She quickly fell in love with the Desert Museum, became a docent, and then joined the Botany staff in 1992. In addition to her botanical work, Kim is an accomplished watercolorist and has illustrated several books, including an award-winning children's book on the saguaro cactus.

MARY IRISH is an author, educator, and consultant. She teaches classes on desert gardening, and the use and cultivation of succulents, woody plants, desert palms, and desert perennials, using a variety of communications media throughout Arizona and the Southwest.

DOUG LARSON is a native Tucsonan who grew up immersed in (and loving) the Sonoran Desert. After receiving a B.S. degree in Philosophy from the University of Arizona, he moved to Southern California and became Curator of Gardens at the Living Desert Reserve in

Palm Desert. In 1979 he moved back to Tucson and worked for five years as a landscape designer at Harlow's Nursery. For the past twenty-five years Doug has been a Horticulturist in the Desert Museum's Botany Department.

GEORGE M. MONTGOMERY, Curator of Botany, began his career at the Desert Museum in 1979 as an animal keeper. Changing direction to the plant kingdom, he served as a Horticulturist, and now as department head, overseeing the functions of the plant collection and botanical programs. In addition to contributions to the Desert Museum's Newsletter and annual conservation magazine, *sonorensis*, he maintains the Museum's Checklist of Birds. George graduated from Northern Arizona University with a B.S. in Zoology in 1973. As a member of the Association of Zoological Horticulture he represents the Desert Museum in this professional, international organization. He has observed plants and birds in Mexico, Canada, Panama, Tasmania, New Zealand, Botswana, Cameroon, and Zambia.

JEFFERY MOORE has been a Horticulturist at the Desert Museum since 2004. He developed his passion for growing plants in Southern California, where his initial interest was in vegetable gardening, later developing into a passion for succulents. He has worked at several Tucson area plant nurseries and currently maintains the Desert Museum's succulent gardens. He is an active member of the national and local Cactus and Succulent Societies.

ERIK RAKESTRAW is a Horticulturist in the Desert Museum's Botany Department. A recent transplant to Tucson, he grew up in Southern California along the Mexican Border, where he developed an early interest in the flora and fauna of the American Southwest. He has worked with horses, rescued and relocated reptiles, and worked for the cities of San Diego and Tucson. After first volunteering with the Desert Museum's Herpetology, Ichthyology, and Invertebrate Zoology Department, Erik interviewed for and was hired into the Botany Department in 2008. Erik enjoys spending time afoot and afield with his wife, Lisa, and sons Noah, 4, and Micah, 1.

STEWART L. UDALL served as a United States Congressman for four terms, 1955-1961. He was the first Arizonan to hold a cabinet position, serving as Secretary of the Interior for seven years in two administrations (1961-1969, under John F. Kennedy and Lyndon B. Johnson). Udall was largely responsible for the enactment of key environmental laws in Johnson's Great Society legislative agenda, including: the Clear Air, Water Quality, and Clean Water Restoration Acts, the Wilderness Act of 1964, the all-important Endangered Species Preservation Act of 1966, the Land and Water Conservation [Fund] Act of 1965, the Solid Waste Disposal Act of 1965, the National Trail System Act of 1968, and the Wild and Scenic Rivers Act of 1968. While Secretary of Interior, Stewart Udall added four parks, six monuments, eight seashores and lakeshores, nine recreational areas, twenty historic sites, and fifty-six wildlife refuges to the National Park System. Rachel Carson's book, *Silent Spring*, 1962, and Udall's book, *The Quiet Crisis*, 1963 (with a Foreword by John F. Kennedy), are widely cited as key forces in launching the environmental movement of the 1960s.

JULIE HANNAN WIENS is a Horticulturist in the Desert Museum's Botany Department. She moved from Kimberly, Wisconsin, to Tucson with her family in 1958. After growing up in Tucson, Julie graduated from the University of Arizona with a B.S. in Agriculture in 1981. She worked for two years as a landscaper for the Tucson Airport Authority, then took a few years off to stay home with her three children Carrie, Patrick, and Maureen. After first volunteering with the Arizona-Sonora Desert Museum, Julie was soon hired fulltime (in 1990) as a Horticulturist; she also serves on the University of Arizona Campus Arboretum Advisory Board. Julie loves to hike and travel with her husband John.

JOHN F. WIENS is the Nursery Horticulturist in the Desert Museum's Botany Department. A native of central California, he received a degree in Agricultural Science-Ornamental Horticulture from California State University at Fresno in 1983. Hired at the Desert Museum in 1985 as a Horticulturist for the grounds, he soon moved into the nursery. On his own time he developed an interest in local desert habitats and began researching and cataloging their floras. Publications include vegetations and floras, plant status reports, and noteworthy plant collections, many of which were of value in promoting the creation of the Ironwood Forest National Monument.

Acknowledgements

The compilation of historical information and photographs for this book would not have been possible without the assistance of a great many good folks, and the authors and editors extend their deepest gratitude to the following individuals: Wynn Anderson (Centennial Museum, University of Texas at El Paso), David Cristiani (Albuquerque), Ron Gass (Mountain States Wholesale Nursery), Don Krock (Cleveland Metro Parks Zoo, for inspiration on the gardens map), Peggy Larson (Desert Museum Archivist), Mike Noel (for taking us into the air for a birds-eye view of the Desert Museum), and Dennis Swartzell (Horticulture Consultants Inc.).

We are deeply indebted to Bill Hornbaker, ASDM Digital Library guru, for assistance in procuring photographs of plants. A huge amount of gratitude goes to Kim Baker, ASDM horticulturist, for his assistance (and training) with photography. Special thanks go to the four guest essayists who contributed their time and recollections to this book project: Scott Calhoun, Greg Corman, Elizabeth Davison, and Mary Irish. Thanks also to the amazing Jeanne Broome and Rhonda Spencer, who contributed their time and photographic expertise freely to this book. And a very special thanks goes to Chris Helms, for assistance above and beyond the call of duty.

Finally, this book might never have been possible were it not for the magic of Linda Brewer's wordsmithing. With her love (and skill) of the English language she is, in the garden of written words, *Peniocereus greggii*.